A Tribe of One

Great Naïve Painters of the British Isles

George Melly

© George Melly, RONA and The Oxford Illustrated Press Ltd, 1981
Filmset by Oxprint Ltd, Oxford
Printed in England by **Haynes Publishing Group**
Sparkford, Yeovil, Somerset, BA22 7JJ, England
Oxford Illustrated Press Ltd, Sparkford, Yeovil,
Somerset, BA22 7JJ, England

ISBN 0 902280 80 5

Contents

Foreword
7 Towards an Understanding of the Naïve
13 The Naïve Thread in British Art
22 Alfred Wallis
34 Scottie Wilson
42 Cleveland Brown
54 James Lloyd
61 James Dixon
70 Because they are Naïve
78 On Finding a Naïve
79 The Register of Naïve Artists (RONA)
80 Bibliography

Acknowledgements

First I should like to thank Stanley Harries of RONA (the Register of Naïve Artists), who, not only suggested I write this book, but fed me much research, many reproductions and innumerable pertinent suggestions.

Next Derek Hill who brought James Dixon to my notice as an essential candidate for inclusion and devoted much time to describing that great painter's history and surroundings.

Finally Eric Lister, longtime friend and fellow jazz-man, and director of the adventurous and seminal Portal Gallery, who offered me freely his knowledge and experience of British naïve and primitive painting.

Stanley Harries would like to thank Mrs Adrian Stokes and Miss Margaret Mellis for information regarding Alfred Wallis, Sir John Summerson for his snapshot of Ben Nicholson talking to Alfred Wallis and Peter Shaw and Robert Lewin for information regarding Scottie Wilson.

Foreword

This book came into being as a result of two fortunate meetings. The first with George Melly and the second with Oxford Illustrated Press. The former I met in 1978 shortly after he had been appointed by the Arts Council of Great Britain to purchase paintings for their collection of works of living artists. During that year he visited an exhibition I had organised at the National Theatre and came across the work of Cleveland Brown. It proved to be an important occasion as he instantly decided that one of Brown's pictures *St James's Park* should be purchased by the Arts Council.

Walking round the exhibition with Melly, I found he had a casual ability, born of years of unprejudiced observation to illuminate in words my rather vague admiration of certain works. We stopped at a picture by Scottie Wilson and he told me a lot about this artist whom he had known and greatly admired. We met on several occasions after this and discussed the works of naïve

artists and the possibility of making a special selection for an exhibition.

All this was uppermost in my mind when in 1979 I met the editor of Oxford Illustrated Press who suggested this book. I agreed to the project as long as George Melly would write the text. I would provide my extensive body of collected material on naïve art and visit private and public collections up and down the country. From this body of material George Melly made his final choice. All the artists included in this book were his personal evaluation. In the first instance I had to select works from hundreds for further discussion and since looking at pictures is an abiding passion it was the greatest pleasure. Hopefully the illustrations in this book will enhance the text and give equal pleasure to those who do not often read books on art.

STANLEY HARRIES
Director, Register of Naïve Artists (RONA)

For Candy

Towards an Understanding of the Naïve

What qualities are necessary in a work of art before it can be defined as naïve? It must above all be compulsive, but compulsion is a quality to be found in much great art which is the reverse of naïve.

'Primitive' is a word often taken to be interchangeable with 'naïve'. This is because all naïve painters have a perception of reality which is shared with one or another primitive culture, but there is a fundamental difference. Primitive art is the product of an integrated society; its artifacts are understood by the entire community. The naïve painter is a solitary primitive, a tribe of one member.

'Childlike'? Certainly a childlike directness of vision is a quality common to all true naïves, but the paintings of children cannot be called truly naïve because, although frequently very beautiful, they share a universality of language. They also lack that sense of a unique personal vision which is the mark of the great naïve.

Yet despite these qualifications, an authentic naïve painting must have the three qualities I've mentioned: it must be compulsive, primitive and childlike.

A true naïve is self-taught though not all self-taught painters are, or at any rate remain, naïve. The artist who is open to influences outside himself, who is or becomes aware of 'Art', tends to be self-conscious about 'the right way to paint'. The naïve has no such inhibitions. He may be obsessed with realising either his inner vision like Scottie Wilson or, with recording external reality like James Lloyd, but his work is never filtered through other art. Henri Rousseau for example, the first acknowledged great naïve, claimed two contemporary French salon painters, Gerôme and Clément, as his only influences, but his work bears no resemblance at all to their academic banality. Alfred Wallis, surrounded by the professional impressionists of picturesque St Ives, disassociated himself entirely from such 'real painters'; furthermore he was so unaware of the possibility of reproduction that on being shown in an American catalogue one of his own pictures, he pushed it indifferently aside remarking that he had one like it at home! I myself can remember Scottie Wilson dismissing with polite incomprehension a painting by Paul Klee which E. L. T. Mesens brought to his attention because of its family resemblance to Scottie's own work. He admired, on the other hand, Magritte not because of his subject matter but for his neat realism.

The shock produced on the spectator by the true naïve picture comes from a feeling of intrusion on a private world. Conscious art, whether good or bad, takes into account the spectator as one point of a triangle of which the other two are the artist and the work itself. However, while the majority of naïve painters may be eager to display or sell what they produce;

this is an afterthought. Wallis for example, though happy to sell his paintings was hurt and irritated by the selectivity of his circle of patrons. The naïve paints initially for himself alone, because he must, because there is no alternative.

A confusion in distinguishing between true naïvety and false is that certain painters, while extremely technically sophisticated and aware of their intentions, have found, in naïvety, a means to express themselves. Stanley Spencer for example, an extremely curious personality, certainly, and highly skilled, used a naïve manner to entrap his homely apocalyptic vision. A more extreme example is L. S. Lowry. He was once considered by all but a few to be naïve, and certainly his reclusive way of life, his appearance and occasional blunt pronouncements seemed to confirm that view. But recent research has uncovered a long apprenticeship and early work of a conventional accomplishment. For reasons of his own, he consciously evolved a naïve style.

Both Spencer and Lowry lived and worked in a

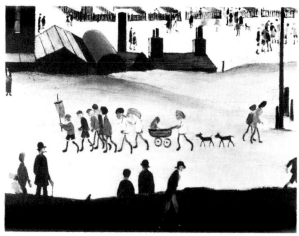

Coll. Tate Gallery

● **L. S. Lowry** The Pond

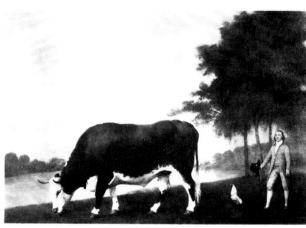

Coll. Walker Art Gallery

● **George Stubbs** The Lincolnshire Ox

time when naïvety had long been recognised. But there are earlier examples of trained artists who exhibit certain naïve qualities of vision within a far from naïve context. George Stubbs for one, a magnificant draftsman, presented his horses and wild beasts with a curious directness far removed from the academic picture-making of his contemporaries. And what are we to make of William Blake? He was thoroughly immersed in art and his muscular figures relate, with bold

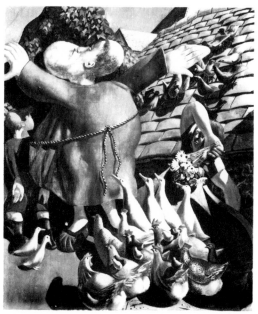

Coll. Tate Gallery

● **Stanley Spencer** St Francis and the Birds

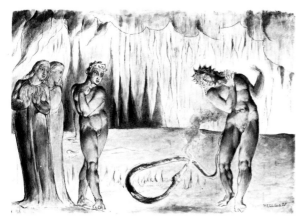

Coll. Tate Gallery

● **Blake** The Serpent

anatomical approximation, to the example of
Michelangelo, yet his whole persona; the
invention of a very personal theology and
mythology, suggests a 'tribe of one'. Moreover
the childlike *Songs of Innocence and Experience*
and the *Prophetic Books*, both bear aspects of
naïvety. But even so it is impossible to assert
with any confidence that he was naïve. He can
more accurately be called 'an outsider'*, and
here we reach another area of confusion: the
difference between those artists who are outsiders
and those who are naïve; a distinction all the
more difficult in that some are both.

At this most extreme, 'outsider' art is
psychotic whereas naïve painting on the whole
tends to be produced by those able to deal with
the world on a day-to-day basis. One could say
that the outsider is primarily concerned only with
his inner world and its expression, whereas the
naïve is interested equally in what is around
him however idiosyncratic his interpretation. Jean
Dubuffet, the promoter of 'Art Brut' defined
outsider art by insisting that its creators must
'draw everything from their own depths', as 'a

* The term, as far as I am aware, is the invention of Victor
Musgrave and Dr Roger Cardinal, organisers of an admirable
exhibition at the Hayward Gallery in 1979, although of course
it was used, in a more general sense, by Colin Wilson in his
book of that name in the 1950s.

chemically pure artistic operation springing from
pure invention and in no way based, as cultural
art consistently is, on chameleon or parrot-like
processes'. This of course applies equally well to
the naïve painter. Alfred Wallis for example,
who towards the end of his life, was demon-
haunted and paranoid, painted, not the monsters
of his imagination, but ships and harbours, yet no
one could deny the result as 'a chemically pure
artistic operation' or suggest that he didn't 'draw
everything from his own depths'. Does this make
him an outsider or exclude him from naïvety? I
don't believe so. At the extremities there are
those who may be confidently described as either
outsiders or naïves, but in the middle-ground
there are many to whom both terms may be
applied. The compulsion to make pictures,
outside a social context where such activity is
accepted, is in itself a proof of singularity. The
simplification that outsider art is pure invention,
as opposed to naïve art being representational is
misleading. Van Gogh for example painted
directly from nature, but he is undoubtedly an
outsider.

Rousseau and the Recognition of Naïve Art

The recognition of the naïve artist was the
result of the acceptance of new cultural influences
around the turn of the century. Until then
primitive art had been considered, in relation to
the ideal of Greek classicism, as a mere curiosity,
evidence of barbarous ineptitude or at best
innocence. In the 1880s, however, Gauguin
moved, via the peasant life of Brittany, to
exploiting the exotic, primitive imagery of the
South Seas. But for all his sympathetic yearning,
he remained outside his subject; a sophisticated
European beguiled by simplicity. His visual
language was far closer to the Japanese print than
the fetishes and idols of the islanders. Only in his
sculptures and bas-reliefs did he approach,
conceivably due to lack of skill, a genuine
primitivism.

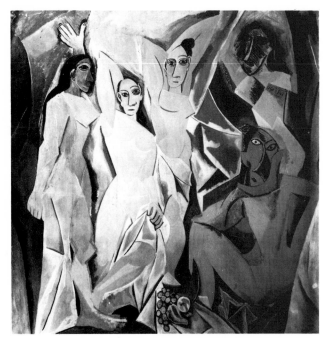

● **Pablo Picasso** Les Demoiselles d'Avignon (1907)

Derain, Braque and Picasso were more successful. They recognised in the tribal masks of Africa a new language without which cubism, 'that marvellous accident', might have been no more than an extension of Cezanne. In the *Demoiselles d'Avignon* for example the figures on the left are influenced by Iberian sculpture—a sign that Picasso was already impressed by primitive art although still recognisably within the European tradition—but those on the right are part of another world; vigorously if awkwardly in debt to the magic formalism of the African tradition. Primitivism, at every level, became the rage. It entered, accompanied by the dissonant chords of Stravinsky's 'Rites of Spring', the European consciousness.

This opening up of sensitivity to primitive cultures and art forms made possible the recognition of the value of 'the tribe of one', the European naïve, and it so happened that working in Paris in those very years was a retired customs official, entirely and correctly convinced of his genius who, without the new climate, might well have remained no more than a figure of fun.

The discovery of Le Douanier Rousseau by the Parisian avant-garde is a well-known if initially confused event. In one version it was Alfred Jarry, author of *Ubu Roi* who was intrigued by a picture of a tiger with words coming out of its mouth at the Salon des Refusées. His obvious interest attracted the attention of the artist, who approached him with a high-flown and absurd explanation of his intentions. This so coincided with Jarry's sense of the ridiculous that he introduced Rousseau into his circle initially as a sort of joke. In another version it was Picasso who on being offered one of the Douanier's canvases on a junk barrow as suitable for painting over, became instantly aware of its originality and value.

What has never become clear is how seriously, initially, the young painters took Rousseau as an artist. Certainly his pomposity, the conviction of his own importance, and his ineptly confident violin-playing, were the subject of much merriment. The famous banquet in his honour in 1908, while taken by its subject as no more than his due, was held in the spirit of farce. Yet none of this ruled out the simultaneous appreciation of his qualities as a painter of which, later on of course, there was no doubt; Picasso and others bought and treasured his work. Even if at first the ludicrous aspects of his behaviour were uppermost in his acceptance, it could only have been a short time before his originality was recognised.

Rousseau was, and has remained the measure of naïvety at its purest, and that naïvety is brilliantly analysed by Marcel Jean in his book *The History of Surrealist Painting* (Weidenfeld and Nicolson 1959). 'The naïve' wrote Jean in collaboration with Mezei 'is someone who, after reaching adulthood, retains intact the childish

● **Henri Rousseau** The Muse Inspiring the Poet

feeling of absolute power, the conviction that desire and reality are synonymous. Naïvety is based on wish fulfilment and includes a very important conscious element; not just the realisation of desire in the manner of the dream but the "realisation of the real", the real embodying in this sense dream and the waking state.'

This is of course very close to the aspirations of Surrealism proper and accounts for the reverence felt by the members of that movement for the true naïve able to accomplish, without effort, that goal which presented such problems for the intellectually aware. In Rousseau's case, and the same is true of several other naïves, 'the real' is difficult to separate from 'the dream'. It is uncertain for instance if Rousseau ever went to Mexico, or served as a soldier under Napoleon III as he claimed. It is more probable that his late jungle pictures were based on visits to the greenhouses of the Botanical gardens and the animals in the zoo, and yet Rousseau, even if this is so, cannot be accused of lying if, as Jean wrote, for the naïve 'desire and reality are synonymous'. Similar doubts have been expressed as to whether Alfred Wallis was ever a deep sea fisherman or visited Labrador—a subject which was the inspiration of one of his most poetic and convincing pictures—but the same justification holds true.

The discovery of Rousseau by Picasso and his friends, and his classification as a naïve or 'Sunday painter', began the ever-widening appreciation of naïvety. This had two distinct effects: first, a revaluation of much work prior to, and following the Douanier's elevation, and secondly, and less admirably, it led to the use of naïvety as a *manner* by many painters who were not in the least naïve. Today this has practically reached the level of a cottage industry.

The vast majority of false-naïves exploit the manner of Rousseau; that is to say precise and hard-edged detail in which every element is given equal value. True naïves, however, are extremely diverse. Admittedly precision is the aim of many of them, but in this book alone, Wallis and Jim Dixon can be seen to be expressionist in manner, while Scottie Wilson had no truck with perspective or modelling. False naïves can be accomplished and charming, and indeed for this reason are often more popular with the general public, but they have nothing to do with 'the realisation of the real'.

Finally it must be said that even genuine naïvety is not in itself a proof of excellence. Just as among trained artists, competence and good intentions are not enough to ensure originality or genius, so too there are many naïves who fulfil all the qualifications necessary to ensure their validity but who remain simply naïve and nothing more. The masters, here as elsewhere, must possess remarkable vision. What they have to say is even more important than how they say it.

The Naïve Thread in British Art

Before attempting to find a naïve thread in British art, it is as well to be aware that for us there are several inhibiting factors which are evident in works of the time and that could be confused with naïvety. First amongst these must be the realisation that well into the nineteenth century there was no photography. To paint horses galloping with all four legs off the ground may look naïve to us but it was an acceptable convention before the camera proved otherwise. Then too, the stiff formality of much Elizabethan and Jacobean portraiture might seem to suggest naïvety when in fact it is a very sophisticated and perfectly conscious language of symbolic exactitude. It's true that this coincided with the High Renaissance in Italy but it must be remembered that not only did styles and theories take much longer to travel, but that the British were drawn by temperament much closer to the Germanic tradition. Furthermore, the advent of Protestantism further isolated us from the idealisation of the Italian masters. Elizabethan and Jacobean portraiture with its flat back-cloths supporting shields, its exact delineation of lace and fur, its carefully realised jewels and linear definition of face and hand, is archaic for its time but the reverse of naïve.

With the triumph of Rubens and Van Dyck during the reign of Charles I the recognition of naïvety becomes easier. Grand aristocratic taste came to be internationalised; 'correct' rules of picture-making emerged. At this point it becomes possible to differentiate between what I shall call, although politically prematurely, Whig and Tory taste. 'The Whigs'—cultivated grandees with pretensions to European culture— embraced the grand manner, while 'The Tories'—lesser gentry, squires and yeomen, their interest divided between the chase and the bottle—remained faithful to the particular and the localised.

Flaxley Abbey painted in 1690 by an unknown hand is an admirable example of Tory naïvety, and comparatively well documented. It shows a squire of Dutch origin awaiting, with visible signs of frustration, the return of a laggardly servant. Except for the clothes the impact, as in most naïve painting, is timeless and frozen. Effect is sacrificed to precision. Admittedly the landscape appears to be generalised but the house itself, its owner, dog and servant, are set down in front of it as though before a back-cloth.

A decade or so later a huge canvas by an unknown hand of a hay-making scene, presents a curious compromise between generalisation of background and naïvety of detail. The sweep of the Gloucestershire landscape, the passage of the clouds, the receding tones of the distant hills aspire, none too skilfully, to contemporary artistic conventions. Yet the foreground detail is so freshly observed as to suggest a different hand. Morrismen, labourers at rest, the squire and his

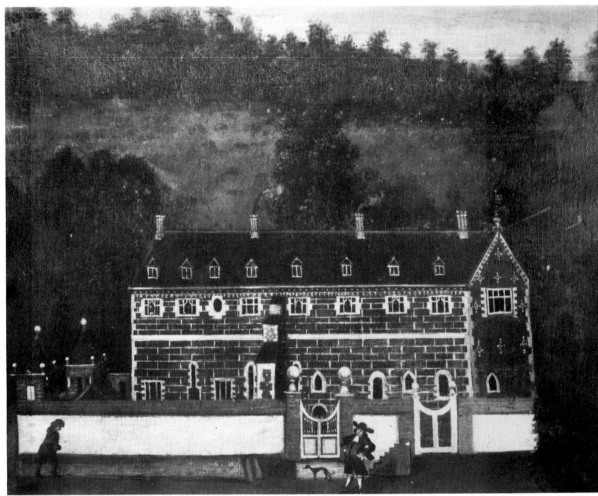

● **Unidentified** Flaxley Abbey, *c* 1690

family on horseback, the formal placing of everything as for an inventory, are at naïve odds with the ambitious pretension of the whole.

The eighteenth and early nineteenth centuries preserved the innocent eye through insular rusticity. The unknown artist of *The Hutton Bonville Dog* is undeniably an authentic naïve. Behind the animal is jammed everything its owner treasured in hard focus. The artist is blithely unaware of 'correct composition': dog, trees, and foreground point insistently to the left.

The same period was a time of agricultural reform and the emergence of scientific stock-breeding. This led to the widespread production of pictures and prints which not only served as advertisements for those animals available for stud but also as a record to reinforce their owners' *amour propre*. In the case of the land-owning grandees, professional artists were employed, but the squires and prosperous farmers tended to make use of talented locals or itinerant sign painters. A certain amount of the resulting

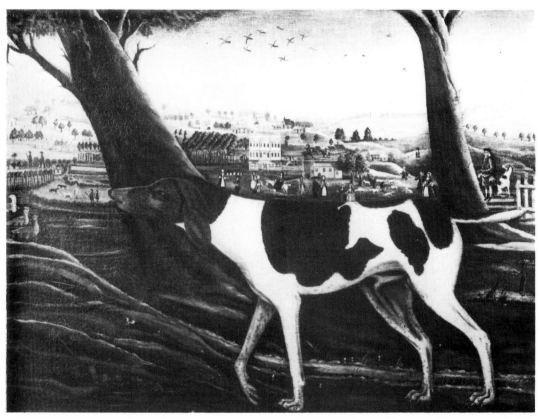

● **'Master of the Hutton Bonville Dog'** The Hutton Bonville Dog *c* 1725

exaggeration of bulk and testicle may be due to the need to emphasise the desirable qualities of the animal, but the precision employed, combined with bold distortion, was the result of an unspoiled eye.

Most of these artists, their work much prized these days by smart interior decorators, remain anonymous but there are some canvases by known hands. J. Clark's *The Royal Rat Catcher* for example is a naïve masterpiece of irresistible vitality and invention, not only as regards the closely observed figures, but in the way they are placed within the almost abstract setting. This whole substream of British painting, fresh and spontaneous as folksong, is as yet unresearched, although *English Naïve Painting 1750—1900* by James Ayres and Andras Kalman has in part

filled this gap. There are few records, and most of the work is either unsigned or by otherwise unknown artists. While the great Whigs were on the grand tour returning with crates of Italian old masters, in some cases of dubious authenticity, their squires and tenant farmers were commissioning these little treasures of innocent anonymity.

It is known that many of these artists were sign-painters, but the inn and shop signs which were their stock-in-trade have long since vanished. From 1625 it had been obligatory for all shops and businesses to display a sign; an edict which gave a great deal of employment to a large body of sign-painters, but in 1763 a new law was passed limiting the number of signs in the streets of London. The effect was similar to that

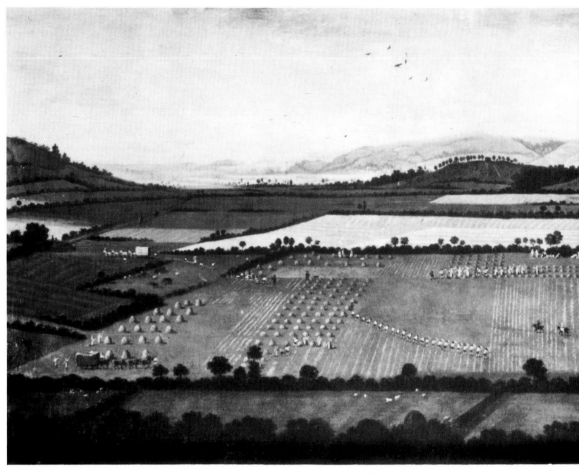

Coll. Museum and Art Gallery, Cheltenham

● **Unidentified** Dixton Harvesters *c* 1725 and details from Dixton Harvesters

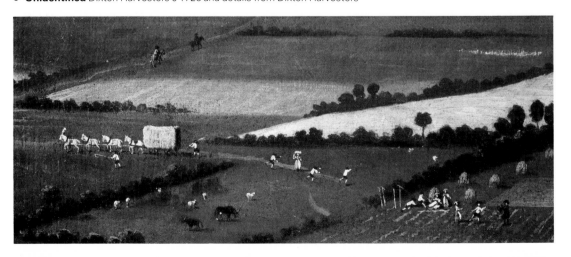

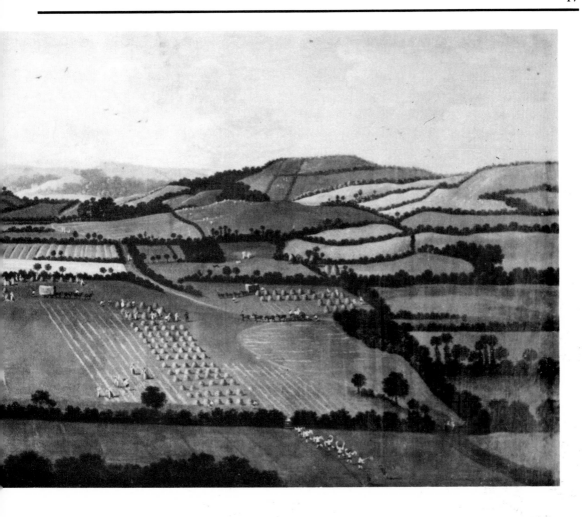

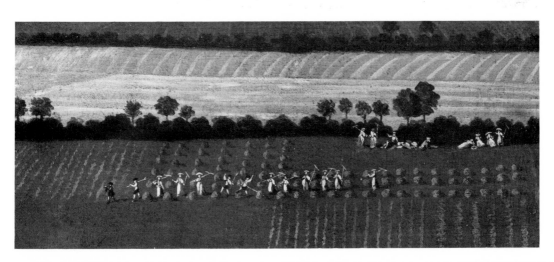

● **J. Clark** The Royal Rat Catcher

produced on the jazz musicians of New Orleans by the closing of the Red Light district. Hundreds of sign-painters were forced to become itinerant and it was they, in the main, who were responsible for the fat cows and sheep painted for the satisfaction of the rustic squires in the late eighteenth and early nineteenth centuries.

We can, however, gain some idea of what they looked like from the engravings of Hogarth. It was Hogarth, that most English of painters, who in 1762 organised what was perhaps the first exhibition of naïve painting in the history of art. His Grand Exhibition of the Society of Sign Painters was held at Bonnell Thornton's Chambers, Bow Street, 'as a protest against the Italian "Grand Manner"'. It was described in an advertisement as 'a most magnificent collection of portraits, landscapes, seascapes etc. . . .' but it is of course now impossible to decide as to whether any satirical intention was present in Hogarth's mind. Certainly at the entrance to the exhibition he placed a sign on which was written

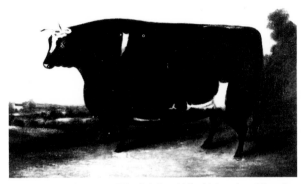

Coll. Museum of English Rural Life, University of Reading

- **James Clark** Thurney Prize Ox 1858

- **J. Mills** Gloucestershire Old Spot Pig 1834

Coll. City Museum and Art Gallery, Gloucester

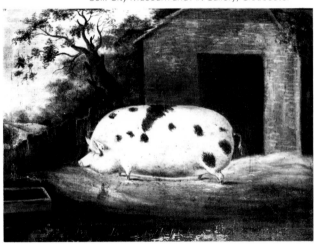

Coll. Mr and Mrs A. Kalman

the following tag from Horace 'Spectatum Admissi Risum Teneatis'—'You who are let in to look restrain your laughter', but if Hogarth himself thought of the show as simply a way of irritating the pretensions of the fashionable collectors, or if he admired whole-heartedly the signs on display is a matter for pure speculation.

This general acceptance of what was accidentally naïve was destroyed by the invention of the camera and the spread of the belief that the photographic image is the only measure of visual truth. Then too the growth of education, art-schools and evening classes, destroyed the general climate in which the innocent eye could survive. Naïve painting, always of course ignored by the cultured, began to lose credibility. Denied a living, the naïve became a special phenomenon isolated by some

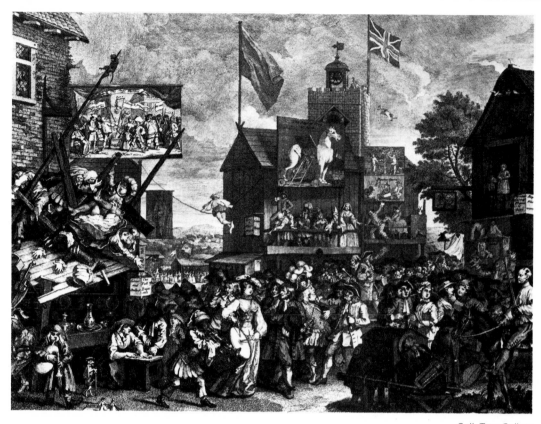

● **Hogarth** Southwark Fair (This engraving illustrates extensive use of signboards)

quirk of character, a solitary primitive painting for himself alone.

There were a few exceptions. Even into my childhood the signs outside the booths at fairs remained naïve in the old sense, and for some reason ships and shipping were the subject of much naïve painting frequently commissioned by their owners or skippers. Tom Swan of Yarmouth for one painted many of the local vessels to order and, although the rigging had to be accurate enough to satisfy his patrons, in every other particular—the crew, sea, sky, and the presence of a toy-like whale—he is authentically naïve.

Another threat to the survival of the naïve can come from sympathetic observers. Walter Greaves, a Thames waterman, was an authentic naïve who painted views and events along the Chelsea waterfront. Whistler discovered him, and, through encouragement, destroyed his pictorial innocence. 'Before that' explained Greaves in his old age 'my brother and I had painted grey, and filled our pictures with numerous details. But Whistler taught us the use of blue and made us leave out detail.' In other words Whistler corrupted Greaves and turned him into a weaker version of himself. Not all the post-Whistlerian Greaves are that bad, but they are in no way comparable with the early work. In fairness Whistler predated the appreciation of naïvety for its own sake. He recognised Greaves' talent but genuinely felt that it could be

improved. The wider appreciation of a naïve has sometimes proved equally dangerous. Scottie Wilson for example lost his magical powers of invention during his final and successful period and became sweetly over-decorative.

The naïve painters who follow are all, with the exception of the Irishman Jim Dixon, British subjects, but this is a matter of accessibility rather than chauvinism. There is no common denominator except authenticity. All were painting either within living memory or are still at work. That the naïve spirit has survived the onslaught of the mass media and the appreciation of the artistic establishment is, in itself, remarkable, but this choice is more than a celebration of persistence. At a time when there is a crisis of confidence in the arts, an almost nihilistic despair, the naïve asserts the value of painting as a revelation. He illustrates precisely the truth of Dubuffet's maxim:

'Art does not lie down on the bed that is made for it: it runs away as soon as one says its name; it loves to be incognito. Its best moments are when it forgets what it is called.'

● **Walter Greaves** Hammersmith Bridge on Boat Race Day 1862

Coll. Tate Gallery

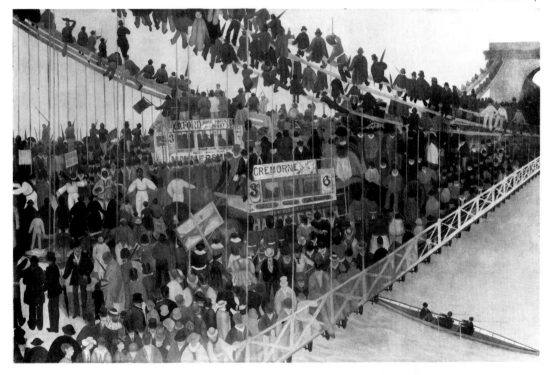

Alfred Wallis

Photo taken by Sir John Summerson

● Wallis (1855–1942) and Ben Nicholson

Wallis is sometimes referred to as 'The father of British naïve painting' but the title is misplaced. To be the father of a school implies disciples but every true naïve starts afresh. Neither, as I have tried to establish in my introduction, was he the first British naïve. What is true, however, is that he was the first to be acknowledged as such and he is treasured for that reason. Although only a few people appreciated Wallis during his lifetime they were a perceptive minority, while his initial discovery was fortuitous enough to come under the heading of what the Surrealists chose to call 'the certainty of hazard'.

One August day in 1928 the young painters Ben Nicholson and Christopher Wood visited St Ives; Nicholson for the first time. Passing the open door of a cottage in Back Road West they saw, nailed all over the walls, some paintings of ships and houses on irregular pieces of paper and cardboard with 'particularly large nails through the smallest ones'. The two artists knocked on the door and met Wallis looking, as Wood remarked, 'just like Cezanne'.* He was working at a table and they bought some pictures from him,

according to Nicholson, 'the first he made'.

At that time, it must be remembered not only were Nicholson and Wood almost unknown but that there were very few people in Britain who were enthusiastic and knowledgeable about modern art. Even so the two artists were able to interest a small but perceptive circle in the old man, amongst them Herbert Read, Adrian Stokes, Geoffrey Grigson and especially H. S. Ede, then an assistant at the Tate Gallery, who was in a position to do a great deal on Wallis' behalf. As a result he was no longer working in total isolation, a figure of fun or at best compassion to the locals and a matter of indifference to the colony of academic painters in

* From an article on Wallis by Ben Nicholson in *Horizon*. Vol. VII, No. 37, 1943.

St Ives. For the rest of his life he sold his work modestly but regularly; a source of great pride to him, and was reproduced and written about in a respectable number of avant-garde magazines and books; a matter of total indifference. Nevertheless, with the exception of Christopher Wood, who was to commit suicide only a few years later, Wallis seems to have had little or no direct influence on the painters among his admirers. Perhaps the subject matter of some of Nicholson's non-abstract work is similar and he claims to have learnt something from the old

recluse, but the use he put it to is at many removes; the effect measured and cool, the reverse of the passionate primitivism of Wallis' best work the formalism of which is instinctive and at the service of his emotional needs.

While Wallis' life, after his discovery by Wood and Nicholson, is well documented he was by then already in his seventies, but his youth and early manhood are the subject of much contradictory speculation most of it of his own making. There are two monographs on the artist. The earlier (Nicholson and Watson, 1949) is by

● **Alfred Wallis** The Viaduct *Coll. Miss Margaret Mellis*

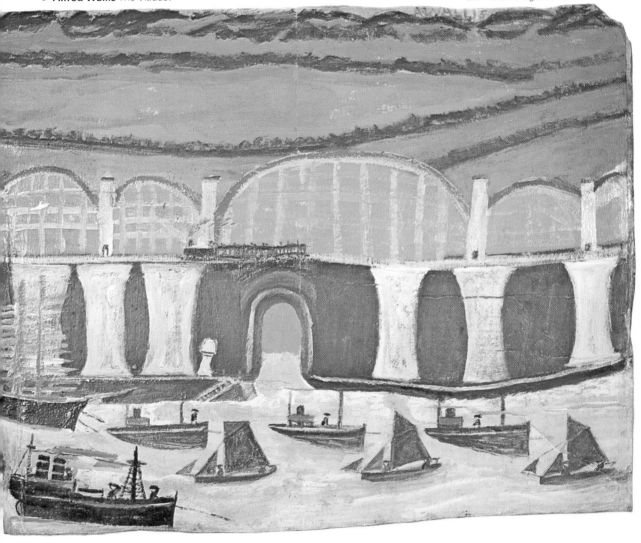

Sven Berlin. Its tone is romantic and poetic and over half the book is devoted to the early life documented, as far as possible, but relying for the most part on the testimony of Wallis himself and those who knew him. Much of this is fascinating, but confirms my view that imaginative but comparatively uneducated people, Blues singers for example, tend to tell the researcher what they believe he wants to hear. The more recent book (MacDonald, 1967) is by Edward Mullins. It has comparatively little biography, most of that qualified by doubts, and the writing is brisk and down to earth. The emphasis is on the work, its quality and significance, rather than the man. The two books complement each other and are of course the sources of my information, but not my opinion or conclusions.

Briefly the facts and myths of Wallis' life and background are as follows. Wallis claimed to have been born on 18 August 1855 in Devonport when his father Charles Wallis, a master paver almost certainly a Devonian but possibly of Scottish origins, was away fighting at the fall of Sebastapol in the Crimean War. Charles' wife came from the Scilly Isles, bore one more child after her husband's return and then died, Alfred being still too young to remember her. Wallis claimed to have had eleven brothers and sisters but the total is more likely to be three. His two older sisters are said to have emigrated to Australia. His younger brother Charles later ran a marine rag and bone business in Penzance and, during his seafaring days, Alfred is believed to have lodged with him until, according to Berlin, they fell out over an inheritance from a gold-mining uncle in Australia (or South Africa) which should have come to Alfred. Charles died soon after of drink, which Wallis believed to be a judgement for his perfidy.

Alfred, short of stature, presumably almost unschooled and of a religious turn of mind, claimed to have gone to sea at the age of nine, first as a cabin boy then as a cook on the deep sea schooners on which he travelled, on at least one occasion, as far as Labrador. Labrador is the subject of two pictures, one of them (in the Tate Gallery) a masterpiece. Later he occupied himself in local offshore fishing.

In 1875 Wallis married a widow, Susan Ward, with whom, presumably after the quarrel with his brother, he had sometimes lodged. She was twenty years his senior, and Alfred inherited several children of which the eldest was senior to his new stepfather. In 1890 Wallis left or claimed to have left the sea, and the family moved to Penzance where, like his brother, he opened a marine rage and bone shop. Of this there is documentary evidence including a photograph, but as to whether Wallis ever went to sea there have been some doubts expressed. Berlin accepted it as fact. Mullins, always more sceptical, acknowledges the possibility that he did not, but on balance thinks that he very likely did. He adds that it doesn't really matter anyway, at first reading a curious viewpoint but, given the confusion between reality and imagination in the mind of this genuine primitive, a justifiable one.

With the decline of the Cornish fishing industry Wallis' business fell off, and in 1912 he shut up shop and moved with Susan, who had borne him two children neither of whom survived, into the small cottage at 3, Back Road

Coll. Miss Margaret Mellis

● **Alfred Wallis** *Below* Fishing Boats Sailing before the Wind

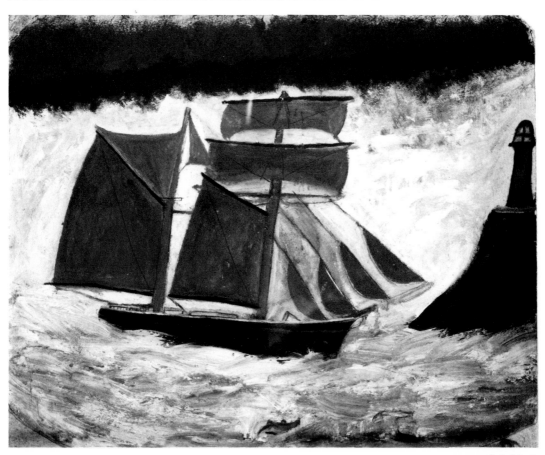

Coll. Private

● **Alfred Wallis** Two Masted Schooner and Lighthouse

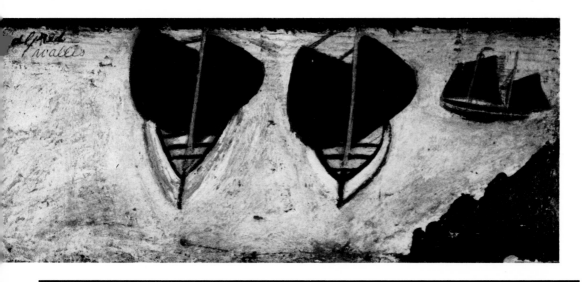

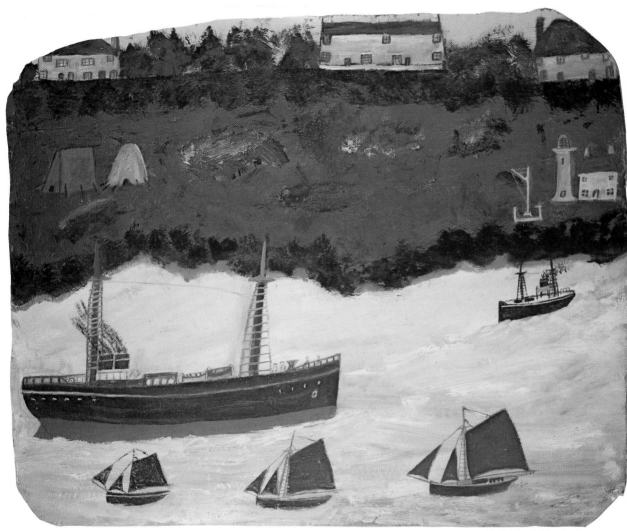

● **Alfred Wallis** Land and Ships

West which he had bought with his savings. He remained there until he was carted off to the workhouse at the end of his life. He kept body and soul together by doing odd jobs until in 1922, Susan died and he was entirely alone. Three years later he became eligible for his pension and, his economic situation modestly resolved, began to paint 'for company'. He was then sixty-eight years old.

Wallis lived to be eighty-six, painting almost to the end. Before discussing the work itself there is one further question to consider; his sanity. Towards the end, although it would seem he showed some improvement in the workhouse, it is certain that he suffered increasingly from persecution mania. This was already present in a milder form when he was quite young and believed himself to have been cheated, perhaps after all was cheated, out of his uncle's legacy. His obsession was intensified in comparative old age

● **Alfred Wallis** Two Boats Sailing up a Wave

Coll. Miss Margaret Mellis

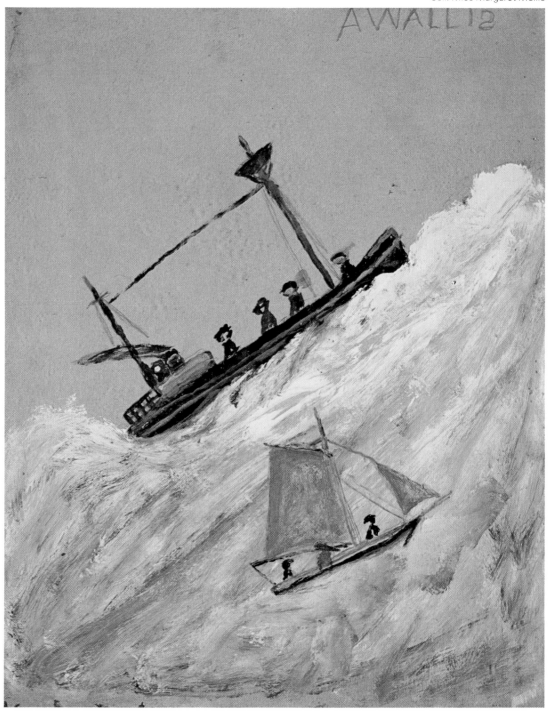

by the notion that some of his savings had been stolen from a chest by one of his Ward stepsons, a mistrust soon extended to the whole family to the point where he would throw away any food they brought him believing it to be poisoned.

His wife Susan, with whom, during her lifetime he had apparently enjoyed a most loving relationship, was elevated after her death far beyond theft or poison. She became in league with his principal adversary, the Devil. It was the

● **Alfred Wallis** Voyage to Labrador

Coll. Tate Gallery

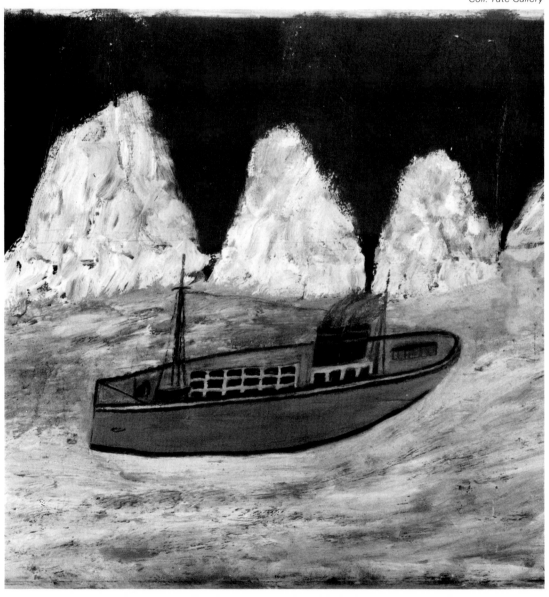

Devil, Wallis believed, who sent those spirits who used to mutter down his chimney, accusing Wallis of being a 'damn Catholic', 'a Methodist', 'a thief' and 'an Irishman'. It was the Devil who persecuted him through the radio, and by extension, anything involving wire. (I have, as it happens, met several people in my own experience suffering from this delusion and often wondered what object they fastened on to before the invention of broadcasting.) According to neighbours his dreadful all-night bouts with the Devil, accompanied by shouting and groaning, would leave the old man completely exhausted. In 1937, to complete that system which paranoia builds to confirm and strengthen its hold, Wallis was knocked down by a motor car, 'Thron under' in his view, and it is a known fact that the local children, animated by that instinctive cruelty towards the solitary eccentric, were given to tormenting him. This too was built in to his belief in systematic demonic persecution.

One is reminded of Evelyn Waugh's Pinfold, but it was Waugh himself who once equated mental instability with an excessive interest in 'the more blood thirsty passages of the Old Testament'. Wallis was not exclusively interested in these but he *was* a fundamentalist and a daily Bible reader; the only other books he possessed were a *Life of Christ* and *In the Wake of the Windships* given to him by Ben Nicholson and much prized. As a staunch Salvationist, he would cover his pictures with newspaper on the Sabbath as a mark of respect, and refuse indignantly to show them to anyone on that day. There is no doubt that old age and loneliness exaggerated his condition but it seems likely that the elements at least were present long before and may have some bearing on his work.

Mullins, with his no-nonsense approach to the painter, plays down the mental condition quoting in defence Dr Roger Slack who believed, even at the end, that the old man was suffering from 'nothing more unusual than senile decay' although even Mullins is forced to admit that the sense of persecution predates the motor-car accident which he thinks to have been largely

responsible for most of the deterioration. He also stresses that to be an untutored primitive painter would, in itself, be enough to convince the locals that Wallis was odd, but in my view the locals were right. It *is* odd to find so strong and persistent a compulsion to paint in old age; in Wallis' case it was also marvellous, but odd nevertheless. It was also odd to have married a woman so much older than himself; without becoming over-theoretical it's possible that the early death of his mother may have played a part here; and many of the stories recorded by Berlin, even if only a proportion are factually true, confirm that Wallis was and always had been an outsider, even though it is evident that with old age, he became more seriously deranged.

One can share Mullins' exasperation with the popular romantic tendency to place the artist's legend before his work; to lay more stress on Van Gogh's self-amputated ear than on his paintings, but with a certain kind of artist, and the primitive outsider certainly falls into the category, the work and the man cannot be considered separately. There is no intellectual intervention, no objective assessment or subsequent modification of the result. Nothing, neither judgement, comparison, nor the influence of others, is brought in from outside. To return to the very origins of art; magic talismen to hold terror and loneliness at bay. They are as spontaneous and as unsought as dreams.

'What I do mosley is what used To Be out of my own memery what we may never see again as Things are altered all to gether There is nothin wat Ever do not look like what it was sence i Can Rember.'

A letter from Wallis quoted by Mullins.

Mullins also quotes a very significant statement made to him by Ben Nicholson to the effect that Wallis 'did not consider his paintings as paintings so much as *actual events*, and that his voyages, whether he really made them or not, were therefore real to him'.

Wallis' work is proof that the true artist invents his means and his language, not for their own sake but to express his feelings. Nevertheless since art is, or should be a magical activity, certain rituals and needs tend to become constant

especially in the case of a primitive painter. As I shall reiterate later, Jim Dixon, the Irish painter, while prepared to accept paints and paper, insisted on using brushes which he made himself of the hairs from a donkey's tail. Scottie Wilson felt the impulse to begin drawing by the chance acquisition of a particular broad-nibbed 'Bulldog' fountain pen. James Lloyd could only realise his imagery through a haze of regular little dots.

In Wallis' case, with a few exceptions (mostly towards the end of his life when his confinement made it difficult for him to get exactly what he needed), he limited himself to a very small range of colours: white, green, grey and brown for the most part with sometimes a little surprisingly tender pink or yellow. What's more he would only use ship's paint and that of a certain brand, and favoured irregularly-shaped cardboard which he got mostly from the local grocer,

occasionally emphasising rather than correcting their irregularity with a pair of scissors.

He almost always worked flat on the kitchen table and, if he had no cardboard available, would paint the table-top, cups, bellows, trays and the walls of the house itself, a flotsam and jetsam washed up by the tide of his inability to control his impulse to paint.

As far as is known he always worked from memory, and this would reinforce his much-repeated statement that he painted 'what used to be', a lost and innocent Eden; Cornwall before the fishing died, before the voices started.

He is thought of mostly as a painter of ships either at sea or in harbour, and most of his work is confined to this subject, but he also painted houses, forests with trees full of blossom or birds,

Coll. Kettle's Yard, University of Cambridge

● **Alfred Wallis** *Facing page* Saltash

● **Alfred Wallis** Schooner in a Storm

Coll. Mrs Adrian Stokes

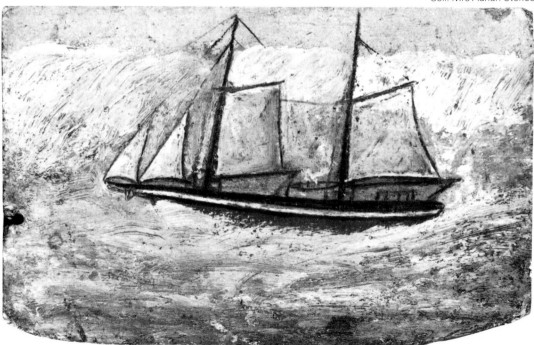

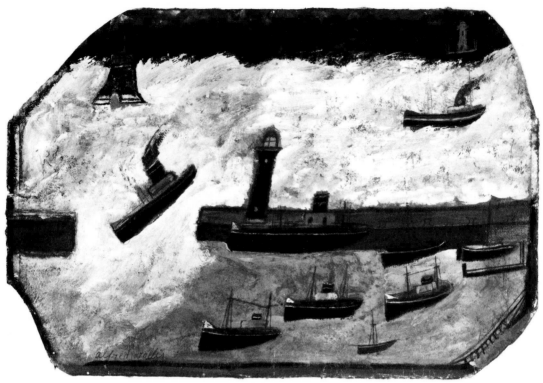

● **Alfred Wallis** Penzance Harbour

animals, an occasional Biblical scene, a very few portraits, and quite a number of bridges mostly inspired, according to Mullins, by Brunel's great feat of nineteenth-century engineering across the river Tamar, near Devonport where Wallis spent his early childhood.

His treatment of the sails, rigging and hulls of ships is as accurate as he could make them, but everything else is as approximate and stylised as a child's pictures; the scale dictated by the emotional need, by what he knew to be there painted in without any of the limitations imposed by what can be actually seen at any one time.

He had no knowledge of nor need for perspective. If a ship was to be depicted sailing towards him he would simply move around the kitchen table and paint it as if viewed from there. Nevertheless he had an amazing plastic sense, an almost abstract feeling for the weight and balance

of the elements involved, one of which was the shape he was working within, however irregular. No wonder Ben Nicholson was so impressed. There is nothing sentimental or picturesque about Wallis' work. The austerity of design and colour puts paid to that.

His limited use of colour seems to have been quite deliberate; his occasional excursions into more vivid hues are usually a mistake. At one level it was probably literal; rocks were brown, grass green and so on. His seas on the other hand were almost inevitably monochrome gradations of greys and whites whereas in Cornwall the sea is often an extraordinarily intense almost Mediterranean blue. Here there is an apocryphal story that when asked for an explanation, he would produce a glass of water proving that the sea has in fact no colour. For all that, Wallis' water has, with its scrambled surfaces, its washes

of greys on grey, its surges of white and eccentric **horizons, an instinctive feeling for the weight** and movement of water; its buoyancy and its menace. He also had an extraordinarily effective trick in certain pictures of putting each ship on its own slab of sea as though isolated on its individual voyage. Equally his rocks and rare icebergs, for all their lack of detail, carry a total conviction, while his harbours seem like safe and welcoming arms.

Berlin proposes, and Mullins opposes, a possible Freudian interpretation of the phallic lighthouses and maternal harbours. My own view is that a sexual element may well have been there at one level, for although it's true that all lighthouses look phallic, Wallis' appear almost absurdly so. This may be due to his disregard of detail alone, but given that painting fulfilled a deep need in his emotional life, given his rather strange marriage and the strong reversal of feelings towards his wife after her death, given the suppressive effect of his extreme puritanism, it would be surprising if no sexual symbolism was involved, however unconsciously. After all he painted, as he admitted, 'for company'.

Nor was Wallis entirely unaware of symbolic elements in his work. Although I've no doubt he would have rejected the lighthouse theory with outraged fury, he once told A. W. Rowe, in explanation of a round table-top painting of mackerel boats with a fish beneath each of them: 'Each boat of that fleet had a soul, a beautiful soul shaped like a fish; so they fish I've painted they aren't fish at all.'

I have a feeling that his pictures are not only 'what used to be' but equally maps of his particularly powerful and rigorously controlled feelings. Such self-censorship exacts its price; malevolently through the voices down the chimney, positively through the certainty and beauty of the paintings.

Wallis' work was uneven—inevitably so in a painter so unaware of what he was up to, of what people admired in his work, of the necessity, impossible to sustain constantly, to equate feeling and the shape it took in front of him. Mullins says, quite correctly that the pictures and drawings he did in the workhouse were inferior, and puts this down to age and senility. I myself wonder if a more central element wasn't the loss of his squalid and flea-ridden cottage; the persecution and voices too were apparently less in evidence in the aseptic and non-associational atmosphere of the institution. The cottage was his heaven and his hell, the seat of many of his memories and of his discovery that he could paint. He is much more than just a freak abstractionist, an accidental aesthetician. His work, clumsy and exact, is moving because he didn't know how to lie. Well-framed and hung in immaculate galleries it looks at times knowing. It's difficult to believe that he wasn't aware of the brilliance of his formal solutions. Nailed to his walls, flat on his table-top the impact must have been very different.

The art critic Alan Bowness wrote:
'When art reaches an over-sophisticated stage, some one who can paint out his experience with an unsullied and intense personal vision becomes of inestimable value'

but he adds, and in part negation of this 'value',
'. . . it must be enough to make *real* artists (which Wallis always said he was not) despair.'

Scottie Wilson

'Kierkegaard, Kafka, Connolly, Compton Burnett, Sartre, "Scottie" Wilson. Who are they? What do they want?'

'I've heard of some of them. They were being talked about in London at the time I left'

'They talked of "Scottie" Wilson?'

'No, I don't think so. Not of him.'

'That's "Scottie" Wilson. Those drawings there. Do they make any sense to you?'

'No'

'No'

The Loved One Evelyn Waugh. This was Waugh's admittedly funny jibe at the contents of a typical issue of Cyril Connolly's *Horizon*, the magazine which, above all others, kept some form of international culture alive in Britain before and immediately after the war. The article on 'Scottie' Wilson, of whom indeed not very many people were talking at that time, was by E.L.T. Mesens, the Belgian poet, collagiste and art dealer who was supporting Scottie and for whom I was then working as an assistant.

One of my jobs was to screen, and in the main discourage, the largely mediocre artists who brought in their portfolios in the hope of a show but E.L.T. himself happened to be in the gallery when the diminutive Scottie in his cloth cap came in, his cellophane-covered drawings in a brown paper parcel, and demanded in a strong Glaswegian accent, that we examine them. There

● Portrait of Scottie Wilson (1890–1974) *Robert Lewin*

was something so engagingly odd about this gnomish figure with his glasses mended with sticking plaster and a Woodbine between his fingers that Mesens instead of melting away as was his habit agreed to look. He realised immediately that here was a true original someone entirely unique and agreed instantly to give him a show. This materialised soon afterwards and quite a number of Scottie's drawings were sold at about six pounds each, although admittedly for the most part to the Surrealist-orientated staff of the gallery and like-minded friends and acquaintances. The critics on the other hand more or less ignored him. E.L.T. was not too delighted to discover, having paid out of the gallery's shaky finances for framing and invitation cards, that Scottie himself had hired an empty shop in nearby Oxford Street and was selling his work there for five shillings a drawing during the run of the show. Nevertheless Mesens persisted in championing the work, introducing

● **Scottie Wilson** Flowering Thought

Coll. Mr and Mrs Robert Lewin

it to the immediately enthusiastic French Surrealists on a trip to Paris and to Jean Dubuffet who at once added Scottie to his museum of 'L'Art Brut'. When the London Gallery folded in 1950, Wilson found another dealer and continued to exhibit with modest but steady success until his death in 1974.

Scottie was more or less illiterate and Mesens, in his *Horizon* piece, adapted a pre-war advertisement which claimed 'The hand that writes can also draw' so that it read 'The hand that cannot write can draw *nevertheless*'. He praised also the infinite patience which created Scottie's world out of thousands of little ink

36

Coll. Peter Shaw

● **Scottie Wilson** Greedy and Swan

Coll. Peter Shaw

● **Scottie Wilson** Evils

strokes adding, in an aside to me (for in those days it would have been impossible to propose it even in an avant-garde magazine), that he found this activity a form of surrogate masturbation. Compulsive it certainly was, and completely automatic, although the artist was prepared to offer albeit at times rather repetitively, an explanation of his imagery: the happy and protective castles and houses, the trees with their birds and flowers, the fishes, the clowns and 'the greedies' those fiercely watchful bulbous faces who menace his innocent world.

Scottie, while eccentric in appearance—he resembled I believe quite consciously, a music-hall caricature of a working-man in his cap and muffler—remained in control of his life and was not unhandy at finding his way through what he always referred to as 'the jungle'. He lived simply, but enjoyed whisky in some quantity and, as Mervyn Levy points out in his monograph (*Scottie Wilson*: Brook Street Gallery, London, 1966), was to divert himself later during

Coll. George Melly

● **Scottie Wilson** Flowers (Early picture)

● **Scottie Wilson** A Greedy

Coll. Private

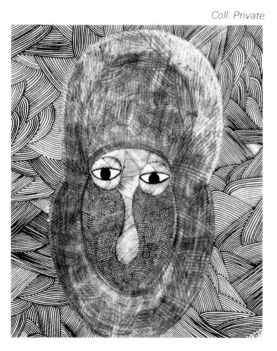

his comparative prosperity, by buying his caps, mufflers and boots from expensive shops in Bond Street. Nor was he unaware of his intentions; he frequently cited William Blake as an ancestor. If he is to be described as an 'Outsider' as well as a naïve, it must be emphasised that there was no trace of psycho-pathology in his behaviour. Even when drunk he remained canny. He claimed to despise intellectuals; he called them 'mouthpieces'; but soon realised that it was they rather than the masses, who were likely to provide his livelihood. Then too, following E.L.T.'s indignant criticism of his extra-gallery enterprise (rather I suspect because he saw the logic of it than because he felt intimidated), he never repeated the self-defeating underselling of his own work, or at any rate only on a modest scale when in need of immediate cash. He knew his own worth. He found his pictures beautiful and rightly so.

● **Scottie Wilson** Evils over the Peaceful Village

He was born in Glasgow, left school at nine, and sold patent medicines with his brother. In 1906 he joined the army, serving in India and then South Africa when he bought himself out. In 1914 he rejoined the army and fought on the Western Front. After demobilisation he returned to street trading—graduating to a small junk shop in the Edgware Road. He went to Canada, returned to England and then went back again to Canada in the 1930s where he sold tinned meat and jam. He settled eventually in Toronto where, in a small shop, he offered old perfume bottles and bought up fountain pens to strip their nibs of gold. Then one day, he happened upon a pen which 'looked like a bulldog with a nib as thick as my finger'. He felt impelled to keep this and some time later, while listening to classical music on his radio, began to draw compulsively on the cardboard top of a table at the back of his shop.

Some of these facts I already knew, but others I discovered in Mervyn Levy's book. It was Scottie himself, however, who told Mesens in my hearing that once he'd started he couldn't stop. He neglected his business and drew constantly. A friend took over the business for him, he exhibited his drawings in the window and soon attracted the interest of dealers and university people. 'Life' he'd say rather too often 'It's all writ out for you—the moves you make.' Eventually he returned to England and one day entered the London Gallery.

Levy cites, as Scottie's principle influence, a Glasgow fountain in a park around which he used to romp as a child. Scottie himself would

Coll. George Melly

● **Scottie Wilson** Untitled (Early picture done in Canada)

uncertainties. His hand dictated what he had to do. As he said himself 'the pen seemed to make me draw and the images, the faces, and designs just flowed out. I couldn't stop.'

I own one of the very early 'Canadian' drawings, small and in black ink alone with no coloured crayon. It's very beautiful but far more like a doodle with none of that tight sense of design which came later. Nevertheless all the elements are already present: the clown (his own self-portrait), the birds, the fish, the somewhat art-nouveau flourishes, but there is less connection between those elements. This didn't take long to develop but it is still easy to tell his early work because he always signed it with a large S and the 'cottie' in front of it, cradled in the lower curve of the capital letter. Later he was to sign more conventionally. Nevertheless, in all his best work, however signed, the design is never completely symmetrical—the balance is subtly maintained without recourse to a mirror image—and yet this too must have been entirely instinctive.

His colour was remarkably rich and harmonious and was produced until comparatively late in his career when he took to coloured inks with nothing more elaborate than cheap crayons, and yet each picture has its own scheme, its own resonance. The tide of colour ripples across the images, sometimes under, sometimes over the pen strokes. Mesens was not being at all frivolous when he showed Scottie those Paul Klees, but Scottie's lack of interest confirmed the totally automatic process which dictated his best work. Personally I didn't find his explanations as to why he did what he did all that convincing; there was something of the patent-medicine salesman remaining in his character; but the pictures themselves needed no verbal embellishment. His hand, for many years, was completely to be trusted.

Then, fairly early in the 50s, something began to go seriously wrong. It was not just his move towards the use of coloured inks although this certainly led to a decrease in subtlety; that curious shimmering quality he had achieved with

occasionally mention totem poles, a memory of his Canadian days, with enthusiasm, and indeed the faces of 'the Greedies', piled one on top of the other, are rather reminiscent of those somewhat alarming objects. It's possible too that there is a certain Indian influence from his time in the army: his palaces are perhaps somewhat oriental with their onion domes: while Professor Endicot, one of his earliest Canadian patrons, has suggested that the lotus-like flowers may have their roots in his visit to South Africa. Even so Scottie's world is an inscape, drawn from his subconscious with no hint of realism or attempt at perspective. The most noticeable feature of it is its assurance. There are no hesitations, no

crayons alone. The more damaging element was that, for the first time his use of images became systemised, their placing decorative rather than compulsive, the compositions far more methodical and less instinctive. He continued certainly to rely on those same elements: birds, flowers, palaces, but the effect was increasingly sweet and decorative. The magic evaporated.

Was it success? Was it over-awareness? Was it the wrong kind of encouragement, too much explanation from the 'mouthpieces'? Naïvety is always a precarious quality, depending as it does on innocence. Perhaps the Greedies left him, and with them his inner tension. One cannot but be glad he finished his life settled and comparatively prosperous, but it is the early Scottie who was the great and unique artist, a cause for wonder. It is of him people will talk.

Cleveland Brown

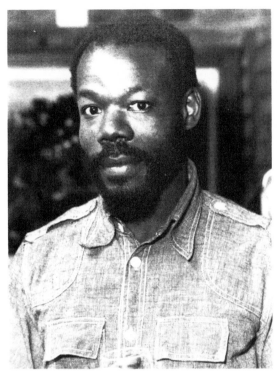

Cleveland Brown (1943–)

Photo Nicky Armstrong

Commissioned to review an exhibition of naïve art organised by RONA in the lobbies and bars of the National Theatre a year or two ago, and reflecting as I walked round how naïvety these days had become so much a manner, a style at the service of the picturesque, and even when genuine, usually over-predictable, I was stopped in my tracks by a comparatively large picture which, while undoubtedly truly naïve, was entirely personal, as solidly constructed as a piece of joinery, richly harmonious in colour, and humorously erotic in subject matter. In front of it I experienced that frisson by which I recognised a true work of art as opposed to a piece of picture-making. The naïvety was not the point of the picture, simply a means by which the artist had been able to solve problems with a head-on confidence which, in these tentative and self-conscious times, would have inhibited a more knowing painter. It had the stamp of a master-piece; that quality which distinguishes an essential image which once encountered, takes its place as by right in 'the imaginary museum', from a picture more or less agreeable, even admirable, but simply after all another painting neither more nor less.

The picture was divided into three planes. In the background was part of Buckingham Palace seen from St James's Park, the title of the work. Then came a bridge across the lake, a simple structure treated almost like a cubist solution, and on it two groups of West Indians; on the right a family group; a child on a bicycle, another sitting on his father's shoulders, a teenage girl in trousers and a sweater and next to her the mother, a neat woman wearing a hat and carrying a handbag. They were all facing the painter as if to have their photograph taken, while on the left, just coming onto the bridge, were two children dressed in that garish but ultra-respectable manner in which the pious Caribbean immigrants advertise that they are on their way to or from a place of worship.

Below the bridge, seemingly unobserved by those upon it, was a scene of innocent sensuality. In the water were two nudes; a voluptuous blonde holding one breast and presented, as they say, in full frontal, and another, in profile, bending

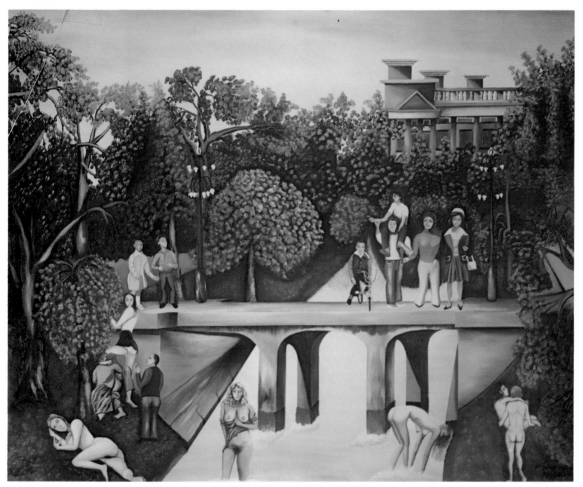

● **Cleveland Brown** St James's Park

over. On the right bank a man was about to carry a compliantly affectionate girl into the bushes, on the left another nude reclined in the foreground whilst behind her a tall girl was undressing coquetishly in front of two male witnesses. I suspected that these figures might have been copied from girlie mags but if so they had none of the aseptic commercialism of their source. They resembled, if anything, the nudes of Lucius Cranock, and were marvellously placed within the elaborate composition.

There was no tonal recession to the picture—another element which added to the sense of rather cubist scaffolding—but the edges of the water, a path on the extreme right, and a magnificent copse of diverse, rather exotic trees helped to establish a somewhat flattened perspective.

My enthusiasm prompted me to approach Stanley Harries, the organiser of the exhibition, with a view to purchasing the picture for the Arts Council. It was the year I had been given a sum of money for the purpose and this I was able to effect. I also wanted to find out more about the

painter. What kind of man could have conceived and executed this extraordinary balance between innocence and craftsmanship? I was told that as this was the private view, he was present and I was taken across the room to meet a small, neatly-made and totally beguiling West Indian, entirely at his ease and confident as to his work. His name was Cleveland Brown and he was, by profession, a master carpenter.

Cleveland was born in Jamaica in 1943. His family belonged to a particularly pious sect, so strict in its application of puritan Christianity that they read no newspapers except religious ones, and forbade their children to watch television or visit the cinema. In 1961, Cleveland, a trained carpenter, emigrated to Great Britain and soon found regular employment. Although many West Indians find English morality rather straight-laced and constricting, Brown on the contrary, away from the severe scrutiny of his family background, discovered in London the key to his personal liberation.

With his professional expertise he soon established himself, while his charm enabled him to become extremely popular with both employers and a wide circle of friends and acquaintances, although eventually at the expense of his marriage to a girl less prepared to sacrifice the rigid standards of their shared religious unbringing. It is tempting to speculate if so instinctive a painter would have come to art eventually in whatever circumstances, but what actually started him off was something entirely concrete. In 1973 he was sent to do some work at Sothebys. For the first time he was surrounded by works of art and it came to him that he might expand his craftsmanship to the painting of pictures.

His first work was a painting of the Post Office Tower copied, but transformed, from a postcard. There was nothing tentative about it. The master-carpenter's confidence proved to be entirely justified. He thought he could do it and he could.

His next picture, children in the playground of Roundwood Park, the respectable North London suburb where he had chosen to live, he entered for a competition in Brent. It won no prize but caught the excited attention of Maggie Tolliday, the local Visual Arts Officer who became, for an enviably small amount, his first collector. It was she who brought him to the attention of Stanley Harries, the organiser of an exhibition of self-taught artists at Olympia in 1977. He was recognised immediately as an outstanding talent. This event escaped my attention, as did an Arena film on his work in the same year, and an article in the *Observer* Colour Supplement. It was therefore a shock to come face to face with the picture of St James's Park that warm afternoon in the summer of 1979. My initial excitement has led me to look long and hard at everything he has painted both before and since.

There are two self-imposed barriers which prevent Cleveland from succumbing to the dangers of his undoubted success. The first is that he works extremely slowly: three pictures in a year at the very most, and sometimes less. The other is that he is extremely reluctant to sell, at any rate not until he has kept his pictures for a considerable time for his own enjoyment and satisfaction.

After the acclaim awarded to the children's playground for example, he again painted another aspect of Roundwood Park, its flower beds, and this took him over twelve months. I'm sure Roundwood Park is a credit to the local authorities, but I doubt it has the paradisial aspect of Cleveland's painting. I'm reminded of how the parks of one's childhhood hold forever in the memory a poetic intensity which even revisiting them in middle age is unable to dispel. Yet the extraordinary thing about Cleveland's picture is that Roundwood Park played no part in his childhood; its municipal beds and neat trees might, you would have thought, have seemed rather prim in comparison to the exotic luxuriance of Jamaica. It can have carried no memories and yet it is charged with emotion while at the same time is an extremely controlled formal statement. Here again are the three planes he favours. In the foreground a curved clipped

hedge running right across the picture. In the middleground the grass is tilted up like a Cezanne tablecloth and on it are the circular medallions of the flower beds, an urn, and a few shrubs. In the background a row of trees make extremely beautiful shapes against a luminous blue sky.

In this marvellous picture; so simple in conception, so magical in impact, are several devices which are always present in Brown's work. The grass for instance, like the bridge in St James's Park, is patterned by certain shadows which are unrelated to light but bind the composition together as in hermetic cubism. Under a shrub on the right of the picture is an area of brightly lit green, almost as if the tree was a lamp-standard, and this gives the impression of a space beyond the plane of the landscape, almost a separate stage, where, in later paintings

● **Cleveland Brown** Roundwood Park Flower Beds

Coll. RONA

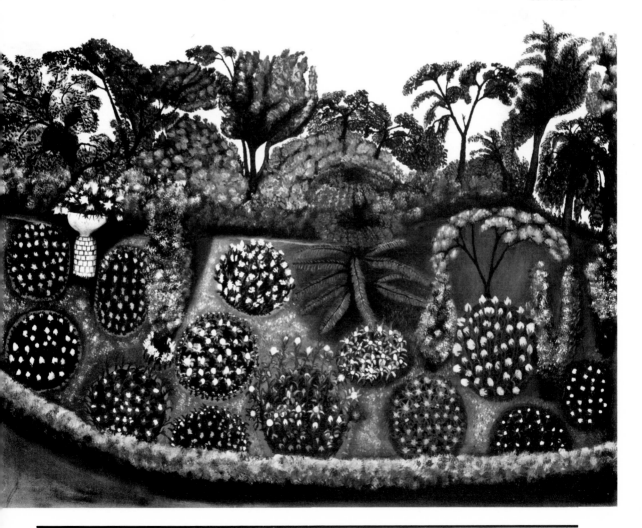

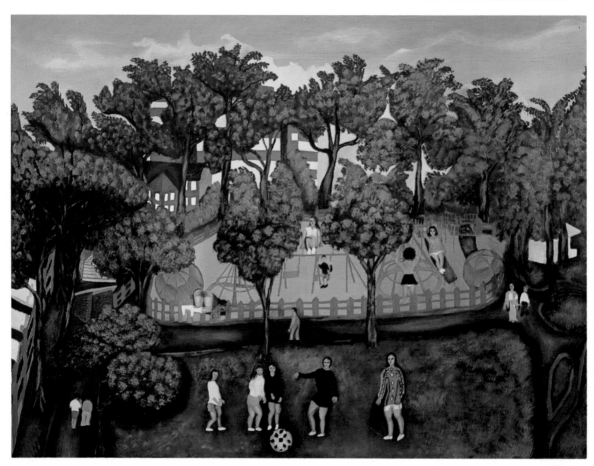

● **Cleveland Brown** Roundwood Park Playground

incidents tend to take place isolated from the main action. Finally there is a tendency to echo certain forms; for example above the 'lampshade' shrub is a large tree which is almost its replica. Yet what makes this picture and indeed his entire work so extraordinary is the conviction that none of these formal motives are consciously worked out. It may be that his training as a carpenter has installed a feeling for proportion and balance, but as in Rousseau, as in Wallis, the language he has invented is there for use, to transmit his excitement at exteriorising his feelings. Almost uniquely in his work, *Roundwood Park Flower*

Beds contains no people and depicts no event, it is perhaps his purest painting.

To date, the same compositonal rules as apply to *St James's Park* and *Roundwood Park Flower Beds*, although never entirely systematically, operate for all Cleveland's paintings. The next element to consider is his subject matter, and here there are three major themes. One the Royal Family: *Princess Anne's Wedding*—the first of these and in my view rather less successful—then *Jubilee Special*, a major painting showing the Mall with the Royal Family walking alongside the Golden Coach the better to be seen, and finally

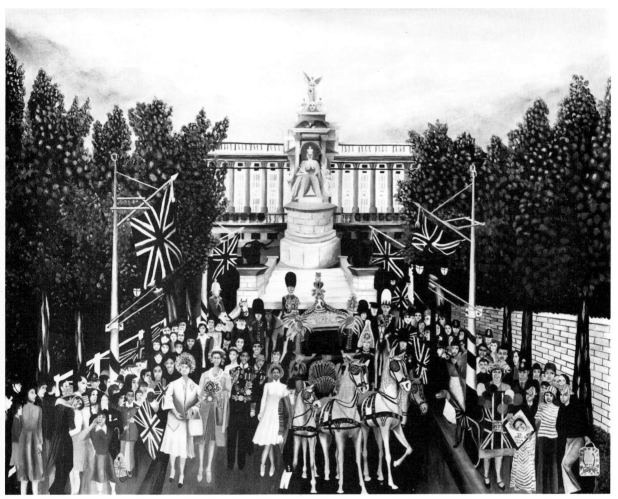

● **Cleveland Brown** Jubilee Special

The Queen Inspecting the Fleet, here reduced to three rather old-fashioned ships dressed fore and aft but with a large airliner flying overhead. It is very difficult to decide if any satirical intention is present and Cleveland, when questioned, smiles politely but remains uninformative. Certainly the effect, while formally splendid, is also slightly comic but there is also, in *Jubilee Special* and *The Queen Inspecting the Fleet* minor irreverent details. In the former the statue of Queen Victoria has bare breasts. In the latter two, boldly

distorted near nudes disport themselves between the vessels.

Next are a couple of paintings which might be considered political, representing as they do the picketing of *Grunwick* and *The Spaghetti House Seige*, yet neither of the pictures seems especially committed. In Grunwick it's true two policemen are restraining a striker on the ground while another, his helmet removed, is looking after a colleague who has been knocked out. The crowded street, between two deliciously painted

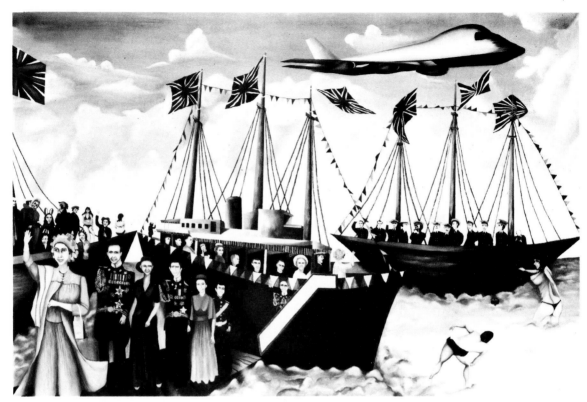

● **Cleveland Brown** Queen Inspecting the Fleet

● **Cleveland Brown** Princess Anne's Wedding

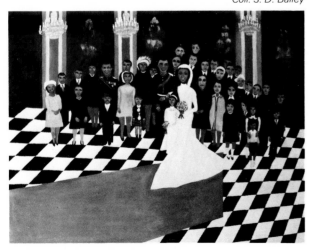

rows of suburban houses with a tube station in the background, is full of strikers and policemen, and there are a large number of banners with such devices as 'Scabs Out' and 'We want an end to Slave Labour'. On the right are three mounted police horses, one rearing, and on the left a TV cameraman. Yet the overall effect is curiously detached; the police, mostly very young, are recorded without rancour, the strikers without idealisation. The feeling of frozen action reminds me of the formalised encounter in Ucello's *The Battle of San Romano*. If Cleveland intended a committed painting he has failed, but if no more than a work of art, he has succeeded triumphantly.

The Spaghetti House Seige is even more

deadpan. Every morning during its progress, Cleveland passed along Knightsbridge on the top of a bus on his way to work. In that the instigators of the affair were West Indian and claimed it was a political act, one cannot help wondering if Brown, in recording it, had some overt purpose in mind. If so it is not apparent. The only signs of the event are a police barrier, several police cars, a single copper and, yet again a TV camera. What he has done is to paint a marvellous city-scape both recognisable and poetic. Cleveland, who works inevitably at home, makes simple sketches as an *aide-mémoire* but these are mere notations and not in themselves of interest. Nevertheless his sense of place, while always reduced in scale, is extraordinarily evocative and distilled to its essentials.

His third theme, of which *St James's Park* is one example, is of the contrast between respectability and erotic hedonism. There is a splendid return to this subject in a large recent canvas called *Speakers Corner*. Here, on the left and right, are two dark-suited men preaching, according to their banners (Cleveland is as keen on written amplification as a political cartoonist), 'God is Love' and 'The Brotherhood of Man'. They are surrounded by their pious and fully dressed followers. Between them, a small naked man proposes that 'Freedom is Beautiful', but those he has converted, both Black and White, and all nude except for some irrelevant hats, seem more concerned with embracing each other or infiltrating the rival meetings than listening to his message.

● **Cleveland Brown** Spaghetti House Seige

Coll. Mr and Mrs C. Barrie

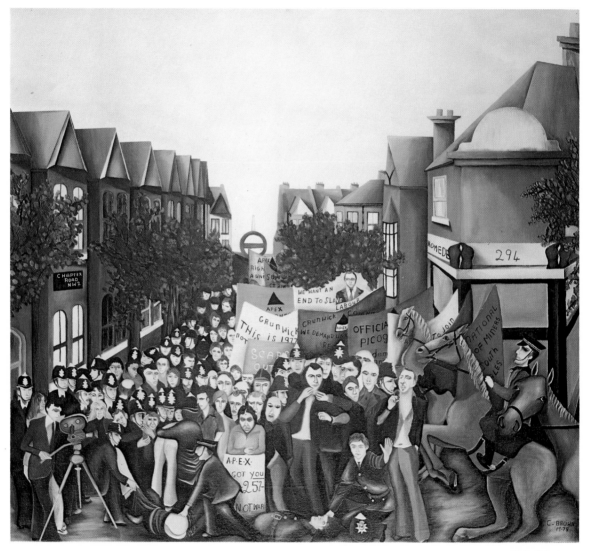

● **Cleveland Brown** Grunwick

Cleveland Brown's nudes tend to have big breasts, long backs, large buttocks and thin short legs, but are nevertheless very sexy.

In the gaps through the trees are two of those stage-like settings I spoke of earlier. In one is a picnic party. In the other a couple make love on the ground while a naked girl approaches. In the air above floats a balloon. The word 'love' is written on it.

The effect of this large canvas is the reverse of prurience or titivation. It has a kind of pure paganism, like D. H. Lawrence without the heavy breathing. No doubt it is a testimony to Cleveland Brown's escape from his ferociously constricted religious unbringing, but it's not at all bitter or censorious. It's tender and funny and, as a painting, a triumph of innocence.

Following his success Cleveland Brown was

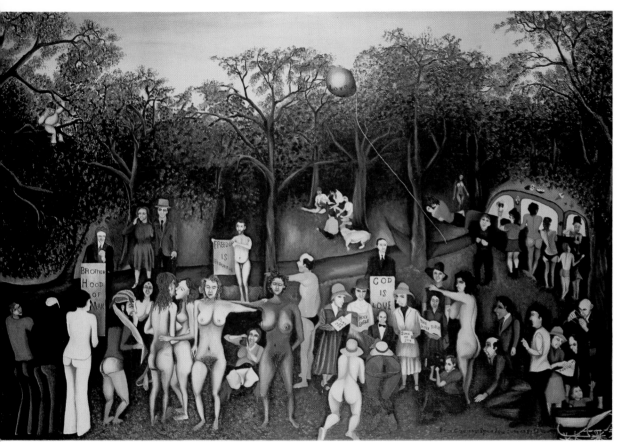

Coll. RONA

● **Cleveland Brown** Speaker's Corner

commissioned to paint two pictures to order. The first was of the *Notting Hill Festival*, that yearly event at which the Caribbean residents of W10 celebrate their culture in the streets around Ladbroke Grove. As a subject one might have thought it invented for the artist, and yet the result was initially disappointing. The crowd in the foreground was lively enough but, above it, the receding houses, joined by the motorway were rather mechanically painted and without incident. Faced with a less enthusiastic reaction than usual, Cleveland himself declared he was unsatisfied and took the picture back again. When he returned it a transformation had taken place. Not only had he repainted a rather pedestrian group of figures to the right of the

foreground, but he had invented devices to join up the top and bottom half of the picture in such a way as to pull the whole thing together. To the left and right two trees rose into the air, partially obscuring the bleak façades. Above the crowd on the left floated an amazing banner depicting three acrobats. The once empty windows were filled with spectators. On the right two girls in bathing suits emerged to watch from the flat roof of a newsagent while a further two figures wave from the roof tops opposite. The animation of the crowd on the ground had spread upwards to animate the picture as a whole. It was an extra-ordinarily intelligent and successful reworking.

It raises of course the question of Brown's naïvety. To pull a picture together in this way

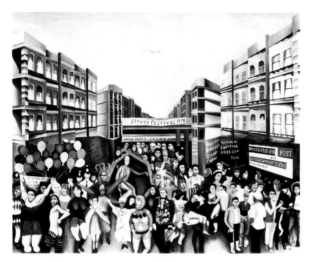

● **Cleveland Brown** Notting Hill Carnival 1

● **Cleveland Brown** Notting Hill Carnival 2

would seem to suggest a certain knowingness and yet I don't feel that it means much more than his response to the feeling that the top half was dull. It's conceivable too that the fact he was asked to paint this picture to order restrained him. It could have seemed initially more like a chore, than an adventure, or a voyage. There were, however, several months between its intial conception and its working. To return to it, to recognise its incompleteness in certain areas, to undertake to correct it voluntarily (for its owners appeared to be quite satisfied) may have excited him afresh. It is now a fine painting.

His most recent commission, that of a foxhunt, was decidedly more alarming. It is one of the

Coll. The London Newspaper Group

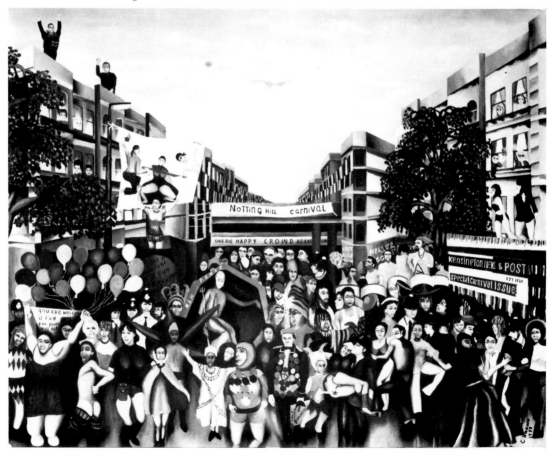

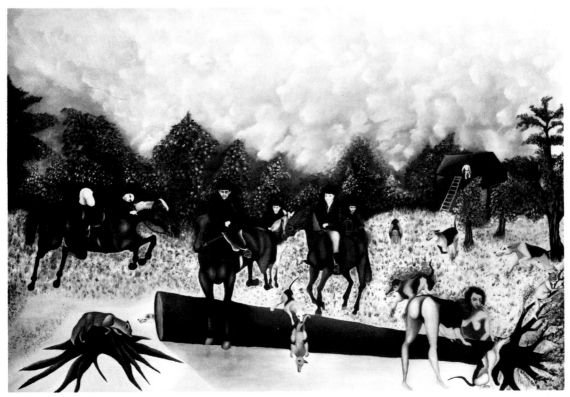

● **Cleveland Brown** The Fox Hunt

most over picturesque of subjects and, it would seem, entirely at odds with everything the painter feels strongly about or that lies within his experience. The result, however, is amazing and, while bearing no resemblance to Munnings or Percy Edwards, it is an extraordinarily imaginative interpretation. Against a mackerel-clouded sky, in front of silvery blue woods of great delicacy, a scene of chaos unfolds. At least five foxes, one caught by the tail, play catch-as-catch-can with the anarchic hounds. The riders, led by a recognisable Prince Charles, but dressed in such a way as to enrage even the most liberal M.F.H., jump this way and that. In the foreground two of Cleveland's voluptuous and,

given the presence of winter, decidedly underclad girls are at work felling a tree. As an accurate depiction of the Quorn it could be found wanting. As a piece of authentic if unconscious Surrealism it is beyond criticism.

On the evidence of this painting, the latest at the time of writing, success and recognition appear to have had no diminishing or damaging effect on Cleveland Brown. Protected possibly by his West Indian origins and fired by his traumatic and joyful escape from his repressive upbringing, he has established himself—since the death of James Lloyd—as our greatest living naïve painter. I believe him to be touched, and I never use the word lightly, by genius.

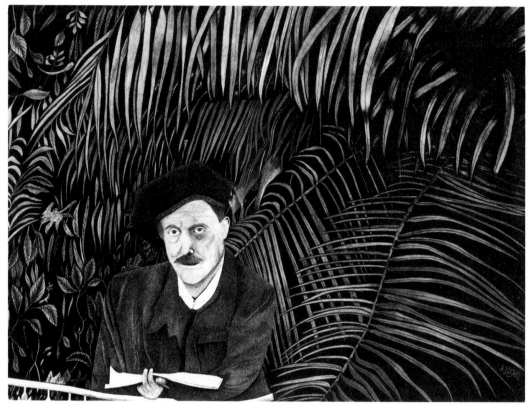

Coll. Portal Gallery

● **James Lloyd** (1905–1974) The Artist as Rousseau

James Lloyd

Like Wallis, like Scottie Wilson, James Lloyd painted flat on the kitchen table. But unlike Wallis, Lloyd didn't move around the table to paint objects as if everything was observed from the same angle. Nor was his world entirely imaginary like Scottie's; he was a realist in the sense that he did aim, although at times approximately, at depth and perspective. He was, however, completely obsessive: everything he painted was built up from a series of dots; a compulsive, infinitely painstaking method of painting that could be compared to Wilson's innumerable penstrokes.

Lloyd himself gave two overt explanations for this method. On one occasion he claimed the idea came to him from painting the leaves of a tree and the realisation that the effect could be extended to cover other less myriad-like phenomena; in fact absolutely everything. On another he pointed out that as the photographs and reproductions in books and newspapers were made up in this way, to use it would give an all-over finish to his work. In this he was correct. Paint texture is frequently turgid in the works of naïves, either that or soap-like and bland. Lloyd's pointillism produces a rather glamorous shimmer which at the same time ensures that the forms, even when the basic draftsmanship is two-dimensional and

shaky, give his objects a convincing, almost monumental solidity. Everything seems frozen at a point in time. In fact in this also his paintings are just like a photograph but then, in a way, that is exactly what Lloyd aimed to paint—hand-made photographs. Nor, perhaps because we are so accustomed to 'seeing' reality through a grid of dots, does his technique reduce everything to the same substance. His grass is grass-like, human beings are made of flesh, cloth has its own textures, animals have wool or fur and so on. The only loss is a certain airlessness.

Compositionally he was impeccable yet highly personal. However simple his subject, his arrangement of the elements was never over-systematic or tiresomely symmetrical. However complicated, there is no sense of forcing the objects into spaces too small to accommodate them; each occupies it proper place both formally and psychologically.

In *John and the Boxer* for example, the child and the trees on the right of the picture might well have produced too much interest in that area, but the sweep of the road towards the left, the steep bank and the comparatively high fence behind the dog, redress the balance. At the same time the space between the dog and the child provides the tension, emphasising the taut suspicion of the

● **James Lloyd** John and the Boxer

Coll. Portal Gallery

● **James Lloyd** James Lloyd and Family

animal, the tentative but uncontrollable curiosity of the small boy.

In *James Lloyd and Family*, where the painter can be seen impassively at work in the midst of what appears to be considerably distracting circumstances, Lloyd jams all the interest onto the left of the picture—his wife, five children, a window, and the painter himself—and yet by such devices as building up the composition towards the tip of a triangle just left of centre, by making all the children look with excitable interest in the direction of something out of frame on the right (a TV set?), this apparently foolhardy risk is both taken and overcome.

A further, and in naïve terms, almost unique ability of Lloyd is that of viewpoint. Most of the great modern primitives assume a consistent

position in front of the subject. Wallis and Dixon for example almost always paint as if from above, but Lloyd has a positively cinematic feeling for the right 'shot'; the position which will best transmit the meaning of what he is painting. The picture *Boy and Horse*, is a marvellous and extreme example of this gift. It is painted from the child's eye view; the confident small boy faces us at eye-level, straining upwards so as to hang from the great animal's bridle harness. The horse's huge head, exaggerated and brought forward as if by a fish-eye lens, looms up into the sky. The result is extraordinary; a statement about strength, trust and gentleness as well as a monumentally formal composition. Some of

● **James Lloyd** Boy and Horse

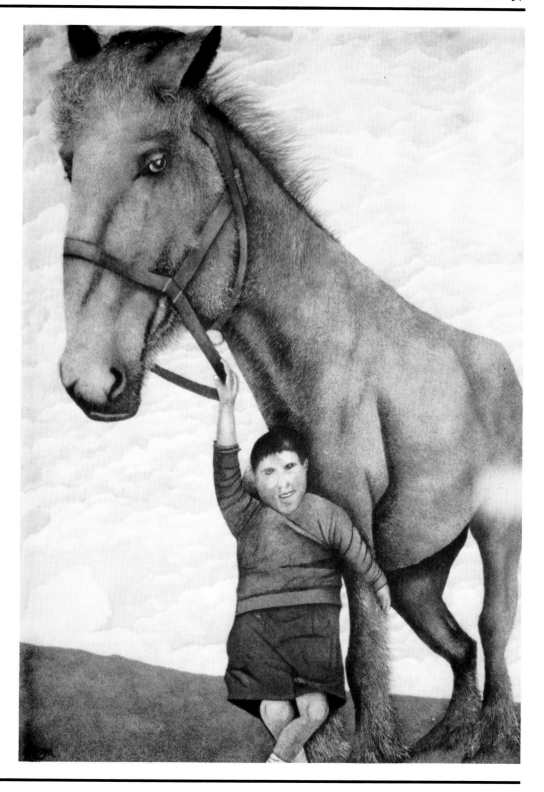

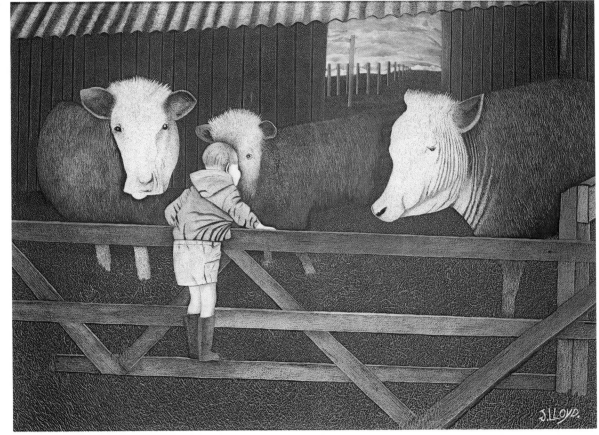

Coll. Private

● **James Lloyd** Boy and Cows

Lloyd's best pictures are about the relationship between children and animals.

As a colourist there is perhaps less to say. He had a natural restraint; no clashes, no vulgarity, while his dots could at times produce an interesting Seurat-like opposition of say blues and yellows interacting side by side across a defined area. But it is not primarily as a colourist that one thinks of Lloyd. I cannot off-hand recall one of his pictures where I was surprised by colour in the way that, for instance, Henri Rousseau enchants us with that subtle progression of pinks in the frieze of flowers across the foreground of *The Painter and his Muse*. Lloyd's colour is always adequate but it is his

psychological insight and instinctive compositional and formal sense which makes him exceptional.

Lloyd was born in Cheshire in 1905 and died in a Yorkshire village in 1974. His forebears worked on the land and so for a time did he, although by the time Ken Russell made the Monitor film about him, the size of his family and the poor wages of an agricultural labourer had forced him into the factory; a one-man industrial revolution. Nevertheless in that film, we watched him cycling home in the evening through farmland and past animals, almost immediately to be surrounded by noisy kids, TV and record-player. Then he began to paint, applying dot after dot as

though in a kind of trance, as though the repetitive gesture was a kind of physical mantra; his world taking shape in front of him while the Beatles wailed and the children scampered and giggled.

Yet Lloyd, unlike Wallis, was not out of this world. He loved the Beatles and painted them too. He did portraits using photographs as an aid although never as an end. As Eric Lister points out, while farm animals and his family may have been his principal subject matter, he was by no means confined to them alone. He would take on mythology, famous personalities, almost anything and yet, in my view, it was the countryside, farm animals and those close to him

who stimulated his best and most original work.

Although he made no fortune, nor indeed enough to live entirely by painting, he was not without admirers during his lifetime. It was initially his wife who wrote about him to Sir Herbert Read whom she had discovered to be living in the area. It was Read who, arriving with his fellow critic John Berger, first encouraged Lloyd, bought his paintings and brought him to the attention of others. Soon he was exhibiting regularly; first at the imaginative and much underestimated Arthur Jeffress Gallery, later, after Jeffress' tragic death, at Eric Lister's Portal Gallery. He was bought by the Tate, and several distinguished private collectors. Then Russell

● **James Lloyd** Cat and Mouse

Coll. Tate Gallery

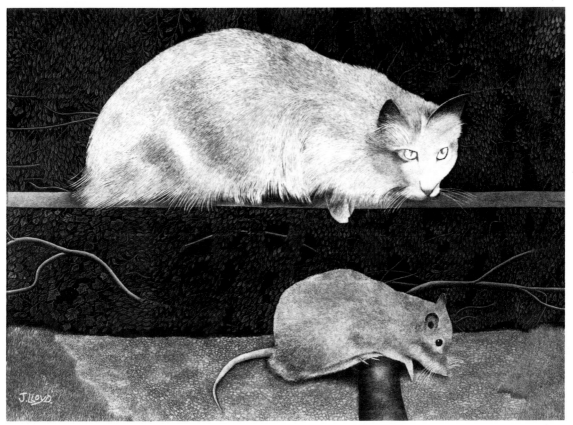

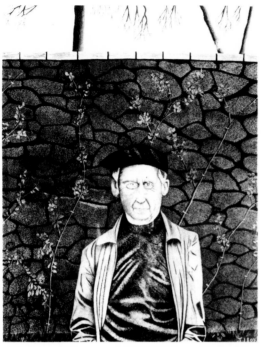

Coll. Penguin Books

● **James Lloyd** Sir Herbert Read

made his film about him—one of that uneven director's most sober and sensitive essays—and later on Lloyd was chosen by Russell to act Rousseau in a more ambitious project on the great French naïve.

Yet this real if limited success seems to have made no difference to Lloyd's inner self; the one who painted the pictures, nor come to that to his outer being; the one who cycled to work and returned home to his noisy home and its magic kitchen table. Lloyd painted a portrait of himself as Rousseau in Russell's film. It's an instructive image in that the background consists of fronds and leaves which are in no way reminiscent of the Douanier's neat fat vegetation. The imitation of Rousseau's jungles is one of the clichés of the false naïve. It is a proof of Lloyd's integrity that when, with every excuse to do so, he had an opportunity to indulge in pastiche, he resisted it; either that or it never occurred to him. It's James Lloyd in a beret who looks out at us from the picture. It is Lloyd's fronds and leaves which frame that quizzical, slightly wary face.

James Dixon

I have in front of me a painting on paper by James Dixon, a gift from the artist Derek Hill who discovered and encouraged this extraordinary naïve.

In the right-hand corner is, as was usual with Dixon, a small rectangle of the paper left uncovered, with its title and date and the artist's signature written in pencil. It reads 'Grey Lag Geese Resting on the West End Lake Tory Island. By James Dixon. 4.5.1969'. It is comparatively rare for painters, unless they are as prolific as Picasso, to note the day and the month.

This precision in no way extends to the picture itself. It is painted with wild expressionist abandon, the brush strokes sweeping rhythmically around the central image, paint splashed on here and there like spray driven by the wind, much of the drawing realised by scratching the end of the brush or some other sharp point into the wet paint to produce a white line.

Of the painters in this book Dixon and Wallis are closest; Wallis also scratched in the details in this way on occasion; but where Wallis is restrained and contemplative, Dixon is an elemental painter. His work suggests a force of nature, and not a very kindly nature at that.

West End Lake is represented by a large, roughly-shaped oval, coloured in various greys: brownish-grey, greenish-grey, blue-grey. There are eight huge geese on its surface, and, were they painted to scale, West End Lake would be no larger than a small duck pond. They do not

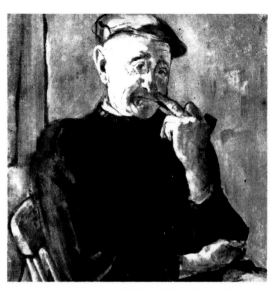

Portrait of James Dixon (1887–1971) by Derek Hill

resemble geese; they are shaped like commas, and look more like fishing floats or, if birds at all, parrots perching on invisible perches. They have dark green heads, a white band round their necks, and then further bands of dark red, blue and white leading down to their blunt green tails. Each is slightly different in shape; all face left, and their eyes, beaks and in some cases underside are scratched in with the brush end.

Behind the lake are some heavy white dabs suggesting breakers and two buildings, one grey, one muddy green, the latter with strange crab-shaped blobs in front of it which may be windows or could be other geese coming into land. There are yellowish areas to the left and right of the lake, and in the foreground an acid-green field with blackish marks on it (perhaps posts pushed out of alignment by the wind), a rectangular building (possibly a farm) and a path leading up to it with a donkey cart heading in that direction. The donkey's eye, its rein, and the man walking behind it are all scratched in outline. The wheel of the cart is the same reddish-brown as the geese's breasts. The geese incidentally are at least four times the size of the donkey, cart and man. They are also beautifully textured and streaked. the general viewpoint, as was common but not

inevitable with Dixon, is aerial. The same was frequently the case with Wallis.

I have described this picture in detail because it is very typical of his work both in style and subject matter. Most of his work relates to the life around him, on Tory Island, a small, rocky, storm-beleaguered place off the coast of Donegal. Only occasionally did some outside event impress him enough to inspire a picture, and that was usually connected with the sea: *The Sinking of the Titanic*, and *Jessy (Gypsy) Moth* are two examples. As a rule though his subjects were the birds and beasts of the island, the fishing and its hazards, 'Muldoons' (herring-whales) caught in the flimsy nets, the great cliffs and the relentless battering of sea and wind.

I have mentioned Wallis several times in connection with Dixon and there are indeed several other parallels: their background as fishermen, their treatment of pictures as events, their lack of finish, their late beginnings, and above all their genius. Furthermore they were both discovered by professional painters. But unlike Wallis, who had begun to work seriously by the time Wood and Nicholson discovered him, Dixon had painted practically nothing before he encountered Hill—only the odd migrating bird or a flower from his sister's garden. What happened was this.

Hill (who lives in Donegal but frequently spends several weeks on the bleak and isolated Tory Island), was painting a large landscape of West End Village from the headland opposite the harbour and the Celtic tower. It was a Sunday and, after mass, a crowd gathered round him. On Tory Island anything counts as an event, and a painter at work was not, in those days, a common spectacle. Hill's pictures, while extremely sensitive, are not difficult to read at a representational level, and I imagine that in general the reaction would have been favourable. Dixon, however was unimpressed. 'I think I

Coll. George Melly

● **James Dixon** Grey Lag Geese. Resting on the West End Lake, Tory Island

could do better' he said. It is very much in Hill's favour that instead of being offended as many a professional might have been, he immediately encouraged the old man and, as he then promised, sent him paints, size and paper (for which he expressed a preference over canvas), but no brushes. As I wrote earlier, Dixon always insisted on making his own brushes from the hairs of a donkey's tail. Hill's generosity was amply rewarded. From then on Dixon painted continuously, sending Hill large bundles of pictures which were frequently dispatched before they were dry and in consequence stuck together. Here again there is a parallel with Wallis and his parcels to Nicholson and others. Like Wallis, Dixon showed no sense of self-criticism; masterpieces and less successful pictures were packed together, but even the weakest was a direct expression of feeling.

The facts in the last paragraph were taken from Derek Hill's short but perceptive introduction to Dixon's first exhibition on the mainland in 1966. He also pointed out that, with the exception of the work of the odd artist who visited Tory Island, it was very unlikely that Dixon had ever seen an original painting. This I find less significant. Wallis after all was surrounded by professionals in St Ives, but his own art was as 'pure' as Dixon's. Scottie Wilson, when shown the work of modern painters allegedly close to his own version, remained entirely indifferent. More significant was the old man's instant conviction that he could do better. This conviction in the innate ability to realise their vision is common to

● **James Dixon** The Sinking of the Titanic

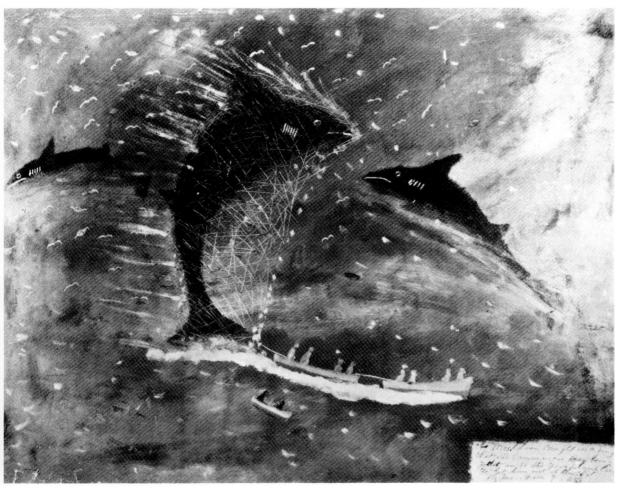

● **James Dixon** Muldoon caught in a ring net

all true naïves. For instance to be confronted for the first time by a great stack of old masters would have inhibited most people, but in Cleveland Brown's case all it did was convince him that he could do as well, if not better.

What is unique, and at first surprising, was the effect of Dixon's work on those around him. As opposed to the mockery or indifference with which his neighbours greeted Wallis, the Tory Islanders not only found nothing odd about Dixon's activities but in some cases were soon to follow his example. Hill maintains that James'

brother Johnny, although less prolific, was his equal and that perhaps one James Rogers, who only did five pictures in all, was also as good. Painting joined fishing and meagre agriculture as a local activity. What's more there is now a new generation of painters working on the island in a much tighter, 'more Hockneyish' style according to Hill. The tradition continues.

At first sight this may suggest the collapse of my whole theory of the naïve or primitive painter as a tribe of one, but on reflection this is unfounded. If anything the painters of Tory

● **James Dixon** The Harbour, Tory Island

Island confirm my belief, for having talked at length to Derek Hill I gather that, as far as it is possible today, the island is a true primitive community, a tribe unspoilt by much contact with the outside world. There is no hotel and in consequence few tourists. There is not even a licensed pub. Visits to 'the country' as the Islanders call the mainland are rare. Dixon himself for example, apart from a short period as a fishing instructor in the west of Ireland, left Tory Island on few and brief occasions. There is a strong and unique culture centring on music, and a beautiful dance called 'The Waves of Tory'. There is much idiosyncracy. Dixon's sister

Grace, of whom he painted a picture *Calling the Cattle Home*, enjoys The *Tatler*, taking a keen if amused interest in the distant social goings on while Dixon himself, somewhat untypically for a citizen of the Irish Republic, was a great admirer of the Queen and Winston Churchill and sent them both portraits. What's more, for all the harshness of the life, there is a fierce devotion to the island; the greatest fear of its inhabitants is of enforced evacuation to the mainland. In consequence, given such isolation and independence, there were no built-in prejudices against the idea of painting; it seemed a perfectly natural activity. Moreover, the absence of

tourists saved Dixon and his fellow artists from that degeneration produced by commerical pressure on so many tribal artifacts—of loss of meaning and cheapening of effect—which has come to be known as 'air-port art'.

Dixon was not without a certain pride and jealousy in relation to his work. On one occasion the painter visited Hill at his house in Donegal and was discovered in the kitchen sitting in a chair and studying, with every sign of satisfaction, a whole wall covered with his pictures. On turning, however, he saw that

Coll. Derek Hill

● **James Dixon** Mr Hill. A present to Mr Hill by James Dixon Wishing him the best of luck. 12.3.65

● **James Dixon** The Fairholm on the Rocks beside Alarin Tory Island. 7 of her crew sunk in raging sea. 1 man saved. 21.3.66

Coll. Derek Hill

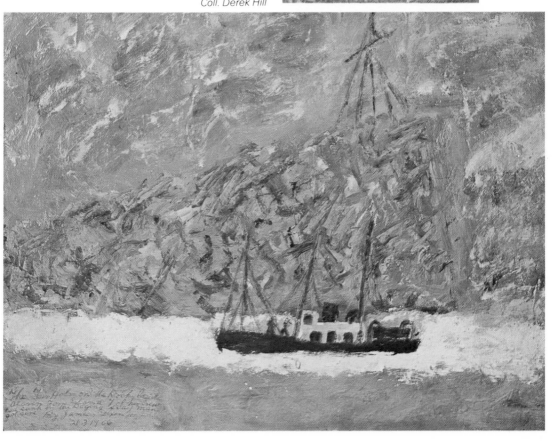

behind him were several examples of one of the other Tory Island artists. His expression darkened.

James Dixon is magnificent proof that there remains in man a wellspring of creativity and poetry. It was his luck to be born into a society unpolluted by the prejudices of mass-production and mass-culture. Unlike his 'muldoon' he was never trapped in our nets.

Coll. Derek Hill

● **James Dixon** 'Jessy (Gypsy) Moth Going Round Cape Horn in a Whole Gale'

Because they are Naïve

Until now I have discussed five great naïves, all but one dead. In this chapter I shall describe six artists, all but two living, all genuine naïves, but none of them of the stature of those whom I felt compelled to examine in depth. This is not to dismiss them. It is inevitable in art that only a small handful should be supremely gifted, but the painters who follow possess that fresh eye, uncontaminated by preconceptions, which is the mark of the true naïve. They delight either in what is about them, or in memory, and possess the ability to transmit that pleasure. The difference is that whereas Wallis, Wilson, Dixon, Lloyd and Brown are unique, the artists who follow could be replaced by others known or possibly unknown. They are all admirable but none of them possess that wholly visionary quality which would make naïvety a secondary factor in their assessment. They are, on the contrary, interesting *because* they are naïve.

Typical of these naïves is the one-time shepherd, carpenter, Fabian and autodidact **Alfred Latchford** (1870–1963). He lived all his life in or around Hemel Hempstead but, like so many naïves, didn't begin to paint seriously until his retirement in 1945 and continued to do so until shortly before his death.

Latchford's pictures, with their characteristically high horizons, are calm, beautiful and truly affectionate in their detailed treatment of a much loved and intimately known landscape. He

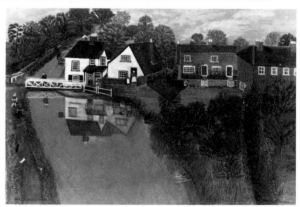

Coll. Gustav Delbanco

● **Alfred Latchford** Winkwell
● **Alfred Latchford** View from the Bridge

Coll. Gustav Delbanco

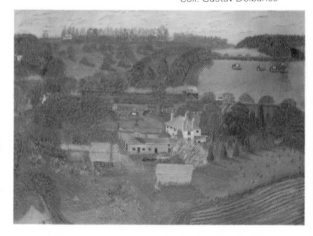

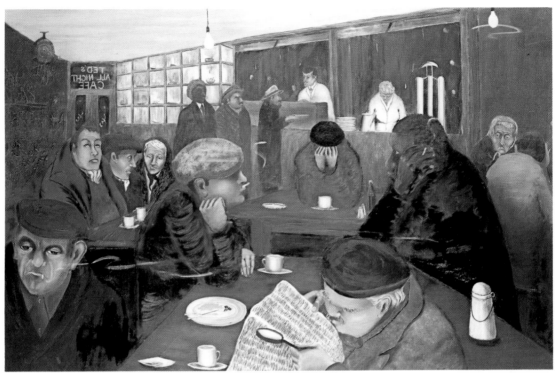

● **Ron Barnes** All Night Café

Coll. Private

was the master of a subtly restrained palette, particularly in his use of greens, that notoriously difficult colour. It would be a pleasure to own one of his small pictures, but not a revelation.

Harsher, more austere, is the work of the taxi-driver and author, **Ron Barnes** (1933–). His subject is the life of London's East End, both domestic and public, before the war. He has a strong sense of composition and great feeling for human character. His colour is grim and low-keyed. There is sardonic humour, but no attempt to charm or seduce. At times, as in his admirable *All Night Café* I am reminded of the paintings of Edward Burra, but there is none of Burra's taste for the louche and depraved. Barnes' night owls are there for warmth and company. His tin baths, overflowing dustbins, sinks, heavy mangles, ornaments, chairs and tables are as eloquent as his people. His cockney world—pre-telly, pre-tower-blocks—is recorded without sentiment-ality but with a wry affection. *Dad Cutting the*

Coll. Private

● **Ron Barnes** Dad Cutting the Kid's Hair

Kid's Hair is a social document as well as a very fine picture indeed.

William Dafter (1901–) is yet another naïve who took to painting after his retirement. He was born a Londoner but during the war,

● **William Dafter** Playtime

working in munitions, he was moved to Blackburn, Lancashire, and has remained there ever since. Unlike most naïves he has two distinct manners. As a rule he uses a hard-edged and detailed style; the *lingua franca* of the primitive, but occasionally, and most movingly, he becomes almost expressionist in his approach. In *The Tears* Dafter has painted a little girl, one hand pressed to her temple, the other jammed into her left eye while from the right a number of heavy tears run down her cheek. Now, as a subject, a crying child is difficult to handle without bathos, especially given those popular reproductions in the style of a debased Murillo. Dafter miraculously avoids any suggestion of fake emotion.

Although by birth a southerner, his long sojourn in the industrial north is the source of his subject matter and it speaks, convincingly

● **William Dafter** The Tears

● **William Dafter** Senior Citizens

enough, with a Lancashire accent. He manages,
however, to resist falling into that fatal trap which
endangers so many naïves and false naïves in
that area; the influence of L.S. Lowry.

Mark Baring is a very different case. He was a
professional dancer with wide experience varying
between the International Ballet and the
Windmill. Whilst temporarily unemployed in
Paris during the 50s he began to experiment as a
painter, but yet again it was not until his
retirement that he took it up seriously and
consistently. He now lives in a minute but
ingeniously arranged garret at the top of a grand
Mayfair House.

His dream-like pictures reflect his theatrical
background. They suggest stage settings
especially in their central focal point and strict
balance. Many of them show a grand house or
palace in the distance, its position established by
receding trees and railings. The colour is lyrical
and fresh, the effect enchanting. There is a
curious balance between a sophistication of

● **Mark Baring** Train in the Valley

intention and naïvety of effect. This usually
implies false naïvety, but in his case it is not so.
A curious compulsive quality saves Baring from
this charge.

● **Mark Baring** Castle

Coll. Private

● **Mark Baring** Isolation

Coll. Mr and Mrs C. Barrie

● **Mark Baring** Garden Centre

Coll. Private

Taploe Johnson is unique in the context of this book in that he was born as late as 1955. An East Ender, a leather cutter by profession, he was introduced to painting by Dan Jones, a youth worker and part-time artist. Now Jones, while making use with considerable charm and skill, of naïve exactitude, is an educated and conscious painter, whereas Johnson is not. Jones is also a politically committed man and many of his pictures have an overt message. Johnson, whatever his views, simply paints what he observes without comment and yet, for me, his pictures say more about the limitations of life in the slum-cleared, tower-blocked East End than Jones' open criticism.

The bleak but powerfully constructed *No Ball Games* for instance shows a disconsolate group of children under suspicious adult eyes in a tenement yard which, with its battered dustbins and high walls, has something of the claustrophobic feel of a prison. Of those pictures I have seen, however, his *Almost Home* is not only the finest, but has none of the quaint appeal of run-of-the-mill naïvety. It shows the approach to the front door of a council flat, high up in a tenement block, built either just before or just after the war. Below the brick balustrade are other blocks, a concrete lamp standard, and a row of small garages. The detailing is perfect: the thin wood of the blue door, the light set into the concrete ceiling, the chalked graffiti, but the painting goes far beyond mere description. It has an irony all the more powerful for being understated. There is a protest there.

● **Taploe Johnson** Almost Home *Coll. RONA*

Coll. The Artist

● **Taploe Johnson** No Ball Games

Ralph Crossley (1884–1966), a northern bricklayer, was born in Yorkshire but, at the age of twenty-six moved to Grimsargh near Preston, Lancs, where he lived until his death. He was, according to Lister, a memorable eccentric, given to begging from his neighbours despite earning a good living from his metier. As to subject matter he would frequently illustrate incidents reported in the newspaper, or invent absurd but convincing allegories such as Churchill knocking out Hitler in a boxing ring surrounded by the over life-size faces of the famous grinning hugely, but equally he would decide on some quite ordinary subject: people skating or a woman in a chair. His quality in either case is beyond his subject matter whether grotesque or banal. What he possessed was a natural feel for rhythmic

● **Ralph Crossley** Skating

Coll. Private

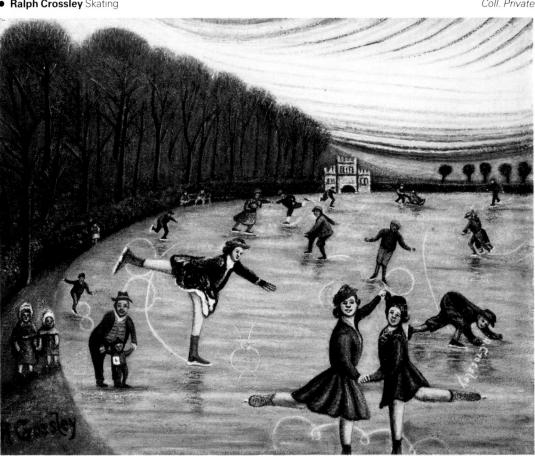

Coll. Private

● **Ralph Crossley** The World Fight For Civilisation

Coll. Private

● **Ralph Crossley** Meditation

composition. In *Skating* for example the sweep of the trees surrounding the frozen lake is beautifully counterpointed by the pattern of the sky, whilst on the ice itself the circles and loops cut by the rather comical skaters have an abstract exactitude. In *Meditation*, the girl in profile, leaning on the back of an upright chair is not especially impressive in herself, but the folds of her dress and the curtain behind her, her elaborate coiffeur, the sweep of her boneless arm, the hang of her beads, the curve of the chairback are extraordinarily subtle and satisfying. If he resembles anyone it is the great American naïve, Morris Hirshfield.

On Finding a Naïve

It is perfectly possible to buy naïve paintings. The most direct course is to visit either the Crane Kalman Gallery, the Portal Gallery or the RONA Gallery in London; you make your choice and pay your money. There is also, however, the greater thrill of discovering a naïve of quality in some unlikely place: a junk barrow, on the wall of a pub or, as in my case, a Pakistani watch-repairer's in Kentish Town.

This particular shop had a side-line in second-hand china, knick-knacks and a few prints and pictures mostly worthless. While waiting to be attended to, I was looking through these—foxed engravings of Cardinals toasting the Chef, sickly reproductions of stags at bay—when I saw, at the back of the pile, a larger picture on canvas. Pulling it towards me, I found, with ill-suppressed delight, a true and extraordinary naïve; inquired the price, which was five pounds and marched off with it.

The subject was a sailor, a member of the crew of HMS *Amethyst* which was shelled on the Yangste river by the Chinese just after the war. It was signed TIKAIN and dated 1950. It is a very strange painting indeed.

For one thing, although the seaman is, presumably, quite old (he has two service stripes and a great many medals),he looks no more than a boy. His right arm leans on a sofa; his left supports a crutch, its handle apparently covered in the same material as the sofa, and its presence suggesting either the loss of a leg or at least a serious injury sustained in the engagement. The true oddness and eccentricity of TIKAIN's vision lies in the background; the reflection in the large rectangular mirror hanging behind the sailor's head. Naturally enough he is reflected but, due I've no doubt to a certain lack of skill, the mirror image appears to represent, not the back of the sailor's head, but the front. This presents an image which is the reverse of the famous portrait of Edward James by Rene Magritte in which the subject regards the back of

Coll. George Melly

● **Tikain Kirton** Self Portrait

his own head in the glass. To the left of the sailor is the reflection of a porthole through which are visible two identical sailing ships firing broadsides at each other with a mountainous coast in the distance. It may be of course a picture of this event, framed in an original manner and hanging on the opposite wall, but it is impossible to say.

The whole picture is crisply painted, subtly coloured, and totally disorientating in effect. It is a particular favourite of my collection but I have as yet been unable to find out anything more about the artist. All I know is that if this is in any way typical of his production, somewhere a naïve master is waiting to be discovered.

The Register of Naïve Artists

Rona was formed in 1978 to provide a meeting place between those extraordinary uninhibited, but often ignored naïve artists in particular and the self-taught painters in general who express themselves with true originality.

During the Queen's Silver Jubilee of 1977 I was commissioned to organise an exhibition of British Naïves at Olympia Fine Arts Fair and later the same year at the National Theatre. There was a good deal of enthusiasm for the quality of the work, and it soon became clear that some kind of organisation was needed to cater for their special needs and to create exhibitions for them. Thus RONA was formed the following year with four main objectives. The first was to promote, publicise and exhibit the works of British Naïve Painters and secondly to maintain a register of their work. Thirdly to encourage public membership of Rona so that all those interested in naïve art can be kept fully informed of all developments, from time to time invited to exhibitions. Finally to maintain an information centre.

Rona Membership

Public membership of Rona entitles you to a free copy of Ronabook (which includes the Register of Naïve Artists in Britain), discounts on various publications on naïve art and invitations to special previews of Rona exhibitions. For full details apply to: The Honarary Secretary, RONA, Ivory House, St Katharine-By-The-Tower, London E1

Bibliography

The RONA GUIDE to the World of Naïve Art, Ronabooks, 1978
Naïve and Primitive Art, Eric Lister & Sheldon Williams. Astragal Books, 1977
Alfred Wallis, Primitive Sven Berlin. Nicholson & Watson, 1949.
Alfred Wallis, Cornish Primitive Painter Edward Mullins. Macdonald, 1967
Scottie Wilson, Mervyn Levy. Brook Street Gallery, 1966
English Naïve Painting 1750–1900, James Ayres, Andras Kalman. Thames & Hudson, 1980.

MAGAZINE ARTICLES AND CATALOGUE INTRODUCTIONS

Alfred Wallis, Ben Nicholson. Horizon Vol VII No 37, 1943
Alfred Wallis, Alan Bowness. Arts Council Catalogue, 1963
Scottie Wilson, E.L.T. Mesens: Horizon
James Dixon, Derek Hill. Catalogue Introduction